Photography

A RotoVision Book
Published and distributed by RotoVision SA
Rue du Bugnon 7
CH–1299 Crans-Près-Céligny
Switzerland

RotoVision SA, Sales & Production Office
Sheridan House, 112/116A Western Road
Hove, East Sussex BN3 1DD, UK

Tel: +44 (0) 1273 72 72 68
Fax: +44 (0) 1273 72 72 69
E-mail: sales@rotovision.com
Website: www.rotovision.com

ISBN 2–88046–463–3

Book design by Dan Moscrop at Navy Blue Design Consultants

Production and separations in Singapore by ProVision Pte. Ltd.

Introduction

This is a book that's as much about images as it is about technique. It's as much about having an eye for a picture as it is about having a mastery of the technicalities of black and white photography. And hopefully, for all the things that are passed on through the words of the photographers who created this collection of incredible images, one of the main benefits of the book will be its ability simply to inspire. If, having seen the quality and the sheer breadth of imagery that makes up these pages you feel the irresistible urge to pick up a camera and to go off and try some of the ideas for yourself, then the book will have achieved its purpose in style.

Portraiture has so many aspects to it that in many ways it's difficult to produce just one book that will do the complete job. Certainly it would be almost impossible for a single photographer using his or her own pictures as examples to try and explain the variety of ways that this subject can be tackled. A portrait can be many things, as you'll see throughout this book. It can be a set of dancing feet, caught up in a blur of movement in a tiny Irish drinking house, a picture where technically everything is wrong but which still oozes spirit and atmosphere and tells you so much more about the occasion than a 'straight' picture ever would.

A portrait can also be nothing more than the work-worn hands of an elderly Portuguese peasant, or the fingers of a master musician caressing the keys of his saxophone. It can be a scintillatingly sharp study of a Welsh fisherman, showing the strain after a hard night's work on his boat, or a beautifully observed candid study of a little girl caught up in a world of her own, pretending that she too might one day be a famous gymnast.

A portrait could be taken with one of the most simple cameras on the market and yet still become one of photography's all-time classics – if the camera's in the hands of a master like Bert Hardy that is. It could just as easily, of course, be originated on a top-of-the-range camera that costs thousands of pounds and which is usually more at home in the confines of the studio.

Portraits can be set up, they can be candids, they might be an instant that is over in 1/125 sec and is never repeated or they could be planned for weeks beforehand. They could even be part of a series that will keep a photographer occupied for years. That's the beauty of this and so many other photographic subjects: the individual can make of it what they will, there's no set agenda that has to be followed.

Even the golden rules that others have established over the years for photographers to follow are there to be broken and turned on their heads, as so many of the photographers featured here take the greatest delight in proving over and over again.

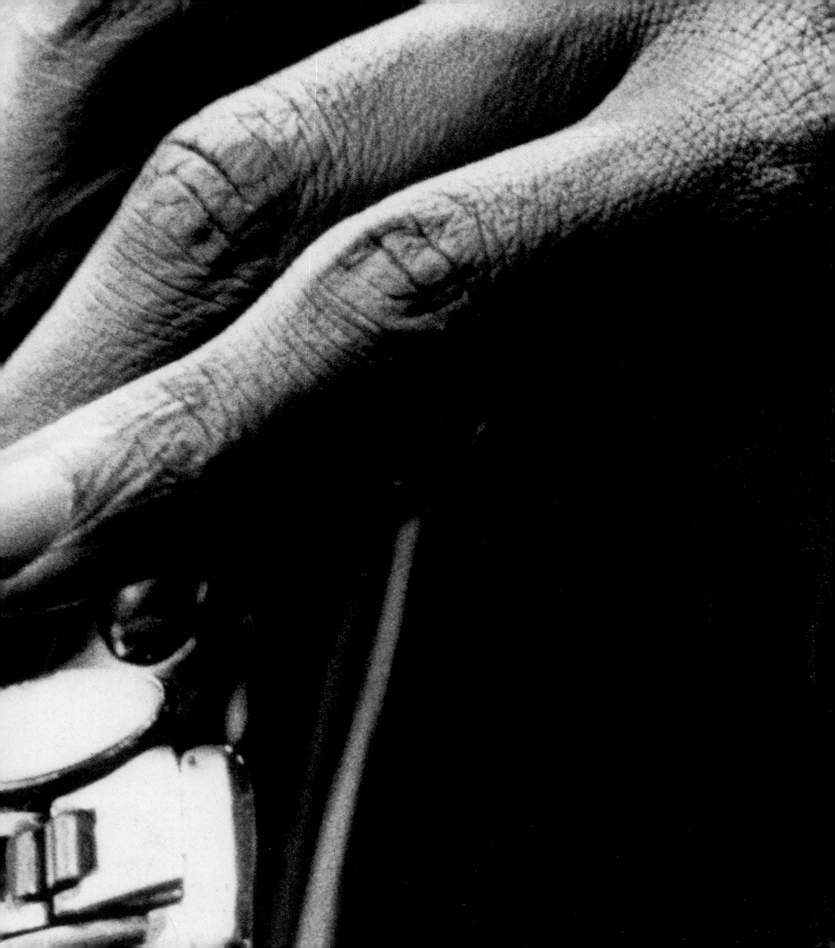

So much for the subject: what about the medium? What is it about black and white that makes it so enduring? Sheer logic should dictate that, with colour film so accessible and of such high quality now, that black and white should have been relegated to the history books long ago. But instead the opposite has happened. It's taken on a new life of its own, and is gaining a steady and growing following across the world.

Black and white is now seen as the natural medium for fine art prints and, as the digital side of photography becomes ever more important, those who choose to indulge in silver halide and the skills of the darkroom will increasingly be seen as artists in their own right.

A whole new generation of photographers is discovering that black and white can offer them a different way of looking at the world, one in which the simplicity and subtlety of tone and shadow triumphs over the distractions of colour. Time and again black and white somehow captures a mood and a feeling that colour, for all its accuracy, simply can't. Perhaps that's exactly the point: photography is about so much more than a simple rendering of what's in front of the camera. We want to achieve an interpretation of life, and colour somehow sometimes gets in the way.

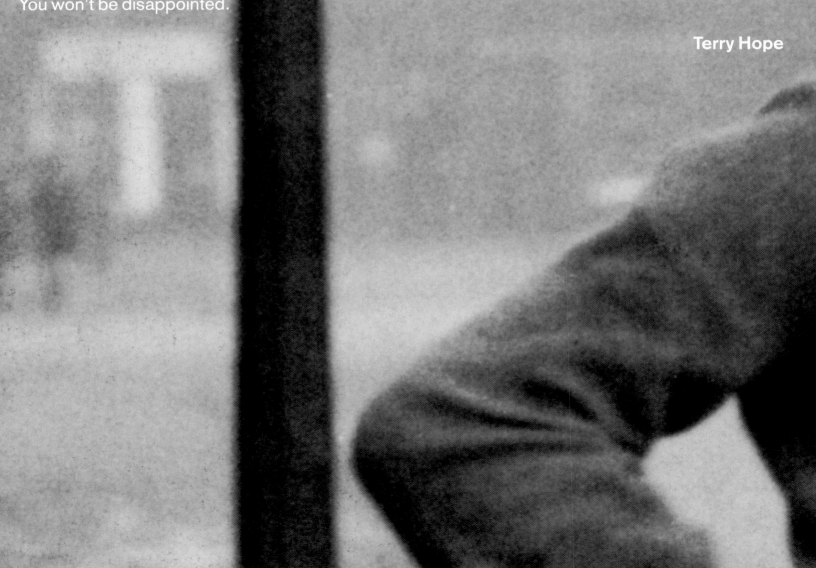

There's also a lot more flexibility built into black and white in the way that it can be manipulated and made to become what we want it to be. Instead of the computer screen, the traditional photographer has the darkroom, where all kinds of miracles can be performed. The rediscovery of ancient toning methods and half forgotten early printing processes has provided an extra dimension, and allowed photographers to produce pictures that wouldn't look out of place in an art gallery. As a bonus, many toners will also give a print a life expectancy of well over a hundred years as well, provided that the ground rules for display are followed.

A glance through the images in this book will show that black and white, thanks to these toning methods, can be surprisingly colourful at times, and equally impressive is quite how effective the final results can be. This is photography proudly proclaiming its history and heritage, and establishing a niche for itself that technological progress in the world of imaging won't erode.

The future of black and white looks secure, and its following will continue to grow as more and more photographers discover its advantages. So, listen to what the photographers in this book have got to say, pick up your camera and get out there and find out what black and white can offer for yourself. You won't be disappointed.

Terry Hope

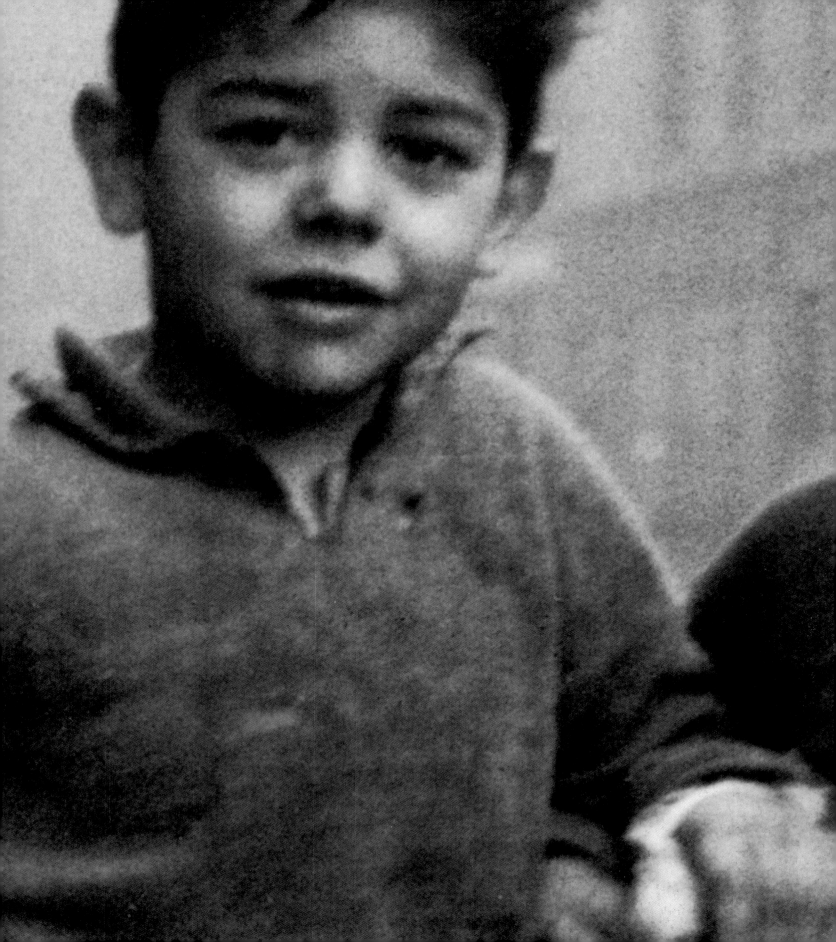

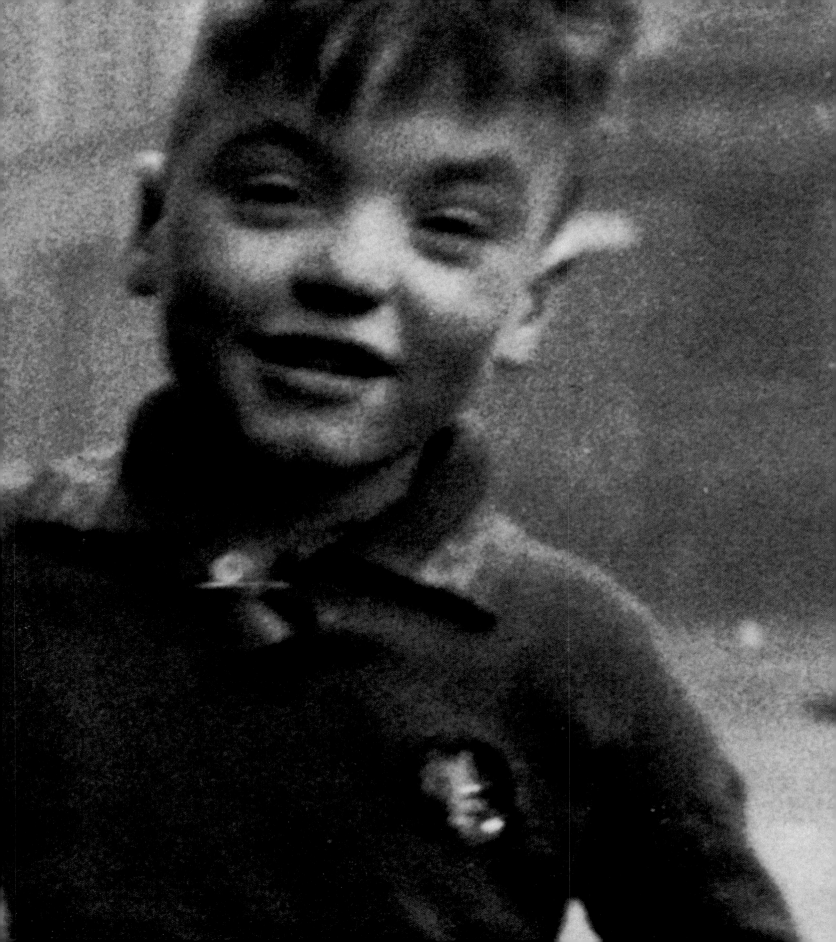

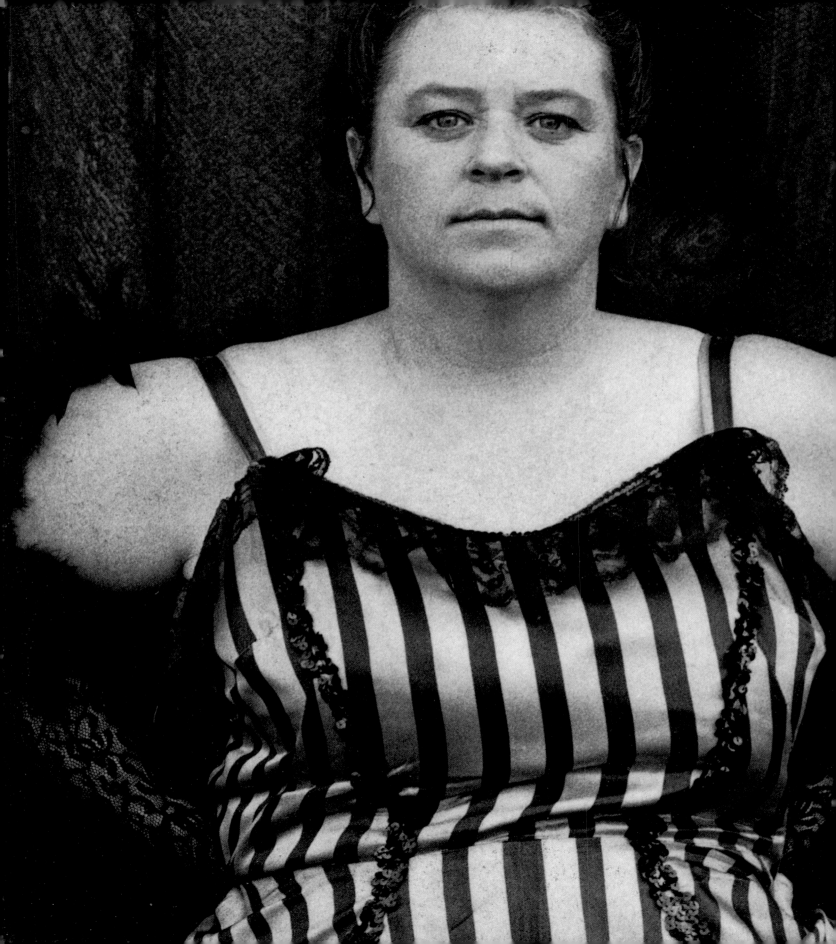

Composition

One of the most classic of the photographic arts. There are numerous rules that can be followed but, as this section makes clear, most are there to be broken. The best photographers develop the art of composing through sheer instinct – put simply, if it looks right, that's all that matters.

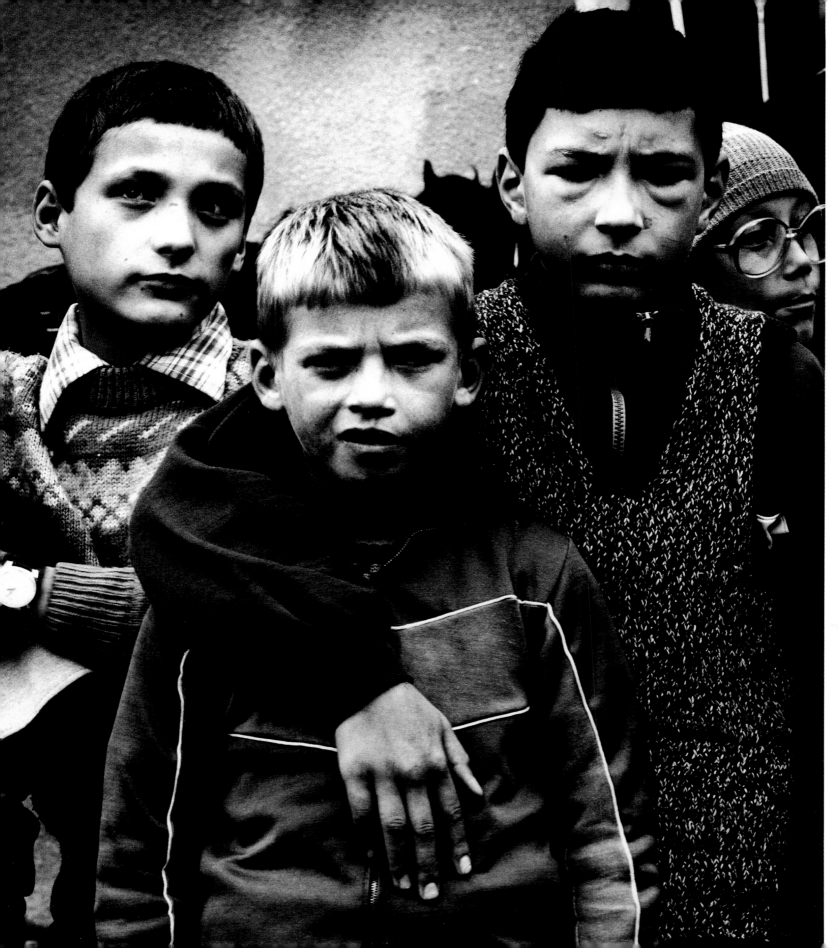

Blind Romanian Orphans 1991 by Eric Howard
Hasselblad 500C, 120mm, Kodak T—Max 400 film.
Exposure 1/60sec at f/3.5

Composition

Photographing children in a group is never easy, particularly when they're excited. I decided with this bunch of blind Romanian orphans that I would allow them to form themselves into their natural group shape. Those who were partially sighted were leading the others around and so they were naturally very tactile, and it was quite normal to see them with their arms around each other. I saw these three standing together and the shape they made was, compositionally at least, just about perfect. The three heads formed an inverted pyramid shape, which I was able to emphasise through a little judicious tightening of the picture at the printing stage. This also allowed me to crop out some of the detail around the boys, such as extraneous hands and so on, that were distracting, although I had no choice but to leave in the boy's head in the background. But I like that touch, it would have been too clinical otherwise.

I also helped to emphasise the strength of the composition by dropping down to my knees to get myself on the level of the boys. This is the only way to photograph children, something I picked up from the days when I photographed children's fashions for **The Times** newspaper.

I'd been talked into the assignment while visiting my dentist. She knew people who were part of a voluntary group working in Romania in the aftermath of the overthrow of Ceausescu. While she was drilling away she asked me if I would be prepared to travel to take some pictures to help with the fund raising for the orphans there. I agreed to go, and visited three to four different orphanages during my visit. Sadly there were a lot of blind children in the country because, I was told, of the heavy pollution of the water supply there.

Eric Howard

Pointer When you're photographing children you have to work fast, because situations will come and go very quickly. This could have been a problem, because I was using a heavy, medium format camera and shooting at quite a slow shutter speed in less than ideal lighting conditions. My solution was to use a monopod, and keep it attached in its closed position to the tripod bush of the camera the whole time I was in this particular orphanage. Because the monopod has just the one leg it's very easy and quick to set up. If I saw a situation I liked I could just press the release button, which allowed the leg to extend to its full length. I could then wedge this on the ground and use it as a support for the camera. The whole process took around half a second, and yet it saved a tremendous amount of camera shake.

'I saw these three boys standing together and the shape they made was, compositionally at least, just about perfect.'

Composition

Composition

Samurai Archers choosing their bows by Gary Wilson
Canon F1, 35mm f/2 lens, Fuji Neopan ISO 400 film.
Exposure 1/250sec at f/8

When I first came across this scene while visiting a display by Japanese Samurai Archers in London's Hyde Park it was the strong uprights that were so dominating that struck me. They could be found everywhere: in the slats behind the figures, the bows, arrows and even the subjects themselves and I wanted to make use of them in my picture. It was a chance to produce something that was well away from the more conventional action pictures that I had taken already: this was a much more subtle moment, as the archers prepared their bows for the next performance.

By using black and white, the rather ugly backdrop which I was faced with, which consisted of the corrugated iron containers that the horses being used for the event had arrived in, became more abstract, and the decision to tone the print helped still further. The lighting, which was coming in quite strongly from the left of the scene, also picked out the shape of the container and helped to give the picture almost a three-dimensional feel, and this allowed the figures to stand out more.

I made the decision to photograph them from behind because it was more in keeping with the contemplative feel of the picture, and it also meant that the eye would take in more of the intricate pattern of the archers' costumes.

Gary Wilson

Printing The print is sepia toned, but I didn't want the sepia effect to lighten the picture down too much. To counteract this I made the print around forty per cent darker than normal, so that even after the initial bleaching back there was still plenty of detail remaining. This ensured that after the sepia bath the final picture took on a deep golden orange tone because the more blacks you have in a print, the more colour you will attract from the toner.

Actual printing was fairly straightforward. I did some dodging around the line of the diagonal shadow that was being thrown onto the background, holding back something like twenty per cent of its density while allowing the three characters to print normally. This ensured that they were able to remain distinct from their surroundings.

Pointer Using black-and-white film will help the photographer remove the influence of distracting colours and will lessen the impact of potentially ugly elements, such as the corrugated iron container that formed the backdrop here.

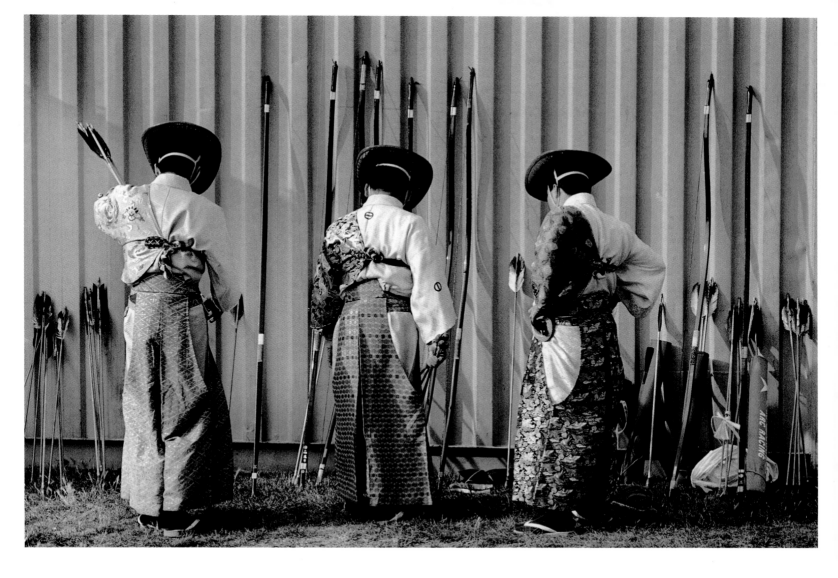

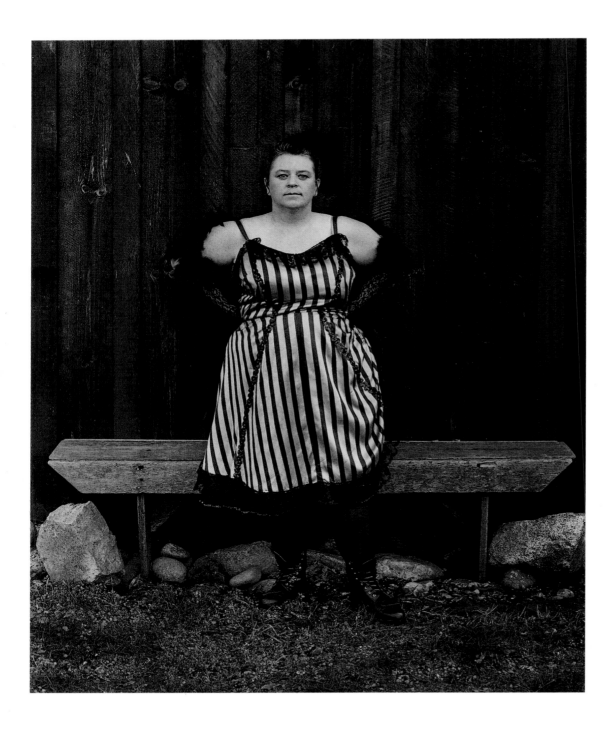

Saloon Girl in Coloma by Ron Bambridge
Mamiya RZ67, 110mm lens, HP5 film.
Exposure 1/60sec at f/11

Composition

I wanted a powerful portrait of this woman, who was dressed up as an old time saloon girl for a re-enactment weekend in the old gold rush area of Coloma, just to the east of San Francisco. The character in her face and the bold pattern of the dress she was wearing attracted me, and I asked her if she would pose for me.

I wanted a background for the portrait that was simple and that wouldn't be distracting and by looking around I came up with the side of a wooden building, which gave me texture without putting any obvious date on the picture. There was a bench there as well, and I decided that this would be the focus of the composition. Its symmetry, particularly when seen against the lines of the planking on the building, was extremely dynamic, and it added immensely to the strength of the portrait without threatening to overwhelm it.

The other element of the composition that has worked well here is subtle, but still has great importance. By taking the camera down to a position just below the eye line it adds power to the portrait, and helps the person to dominate the picture more.

There are so many straight lines in this composition, but they all work together rather than against each other, and they help to make the picture stronger. I completed the image by asking my subject to pose with her hands on her hips and to look straight into the camera for the kind of direct and challenging portrait that I feel often works the best.

Ron Bambridge

Technique Shooting portraits outdoors allows you to work with available light, but it's very rare that direct sunlight will work well. It's usually far better to work either in conditions that are bright but cloudy or to move the subject, as here, into a shaded area where the contrast is more manageable. Not only will the results be far more flattering, but also you'll avoid the situation where your subject might be squinting into the light while you're trying to set your picture up.

Pointer The more you standardise your equipment and working methods, the more you'll develop an intimate understanding of the way it affects your photography. I used the same film – Ilford's ISO 400 HP5 material – throughout my personal project in the American west, and came to know its every quirk. It gave me the slightly gritty quality that I wanted, I knew how it would handle different lighting conditions and, if required, I could push it one or two stops and still be confident that the results would be to my liking. Had I changed films on a regular basis it would have been one less element I could have relied on.

'By taking the camera down to a position just below the eye line it adds power to the portrait, and helps the person to dominate the picture more.'

Composition

Walter by Eric Howard
Hasselblad 500C, 120mm, Agfa 100, Metz 45CL/1 flashgun.
Exposure 1/250sec at f/8

Several people have seen this picture and have thought that it's a computer manipulation, but the secret is entirely down to careful composition.

I went to the local stables one day to see a girl I knew who was mad about horses, and she showed me this trick she'd learned where her horse would lean its head around her. There was no chance of a picture at this point – the surroundings were too messy and she was wearing jeans and a shirt – but the idea stuck in my mind that we'd set the picture up again one day when the circumstances were more suitable.

Eventually I heard that she and her horse were going to be attending an event, where she would be wearing her full riding outfit. The picture I had in mind would have looked quite surreal: I wanted her standing there with all the paraphernalia of the event behind her, the 60 or so horse trailers, the two hundred people and all the assorted kids and dogs.

For the picture to work, however, the ears of the horse had to be going in the direction the horse was facing, and however hard we tried we could only get this to happen when everything was happening in front of it. So I had to take the picture using a plain field as the background, and this made it all look a little more set up than I wanted it to be, but it still appeared amazing through my viewfinder.

I arranged my subject very carefully so that her coat covered much of the body of the horse, and we encouraged the tail of the horse to flick around for further effect. I positioned them in the centre of the picture, and allowed some space around the pair to give the composition room to breathe, and took the picture hand-held.

Eric Howard

Technique There was no direct sunlight falling on the face of the horse or the front of my subject, and had I left things as they were this part of the picture would have been unacceptably dark. So I decided to add a touch of direct on-camera fill-in flash to lighten this area up. This technique depends on its subtlety for its effect. Usually if you can see the flash, the picture hasn't worked. The picture was metered at f/8 for a correct exposure, and so I set the flash to give a light output of f/5.6, one stop underexposed. This allowed it to blend in with the ambient lighting, while it still had enough power to lift the shadows and to balance out the picture.

Pointer Believe in your own photography. I was extremely pleased with this picture once I'd taken it, but the response of a couple of people to it was quite negative and I started to wonder if it was so good after all. In the end I decided to enter it into the Royal Photographic Society's Annual Print Exhibition only as a final print to make up the numbers in a set of four. It went on to win the event's top award, and I realised that I should never have lost faith with it.

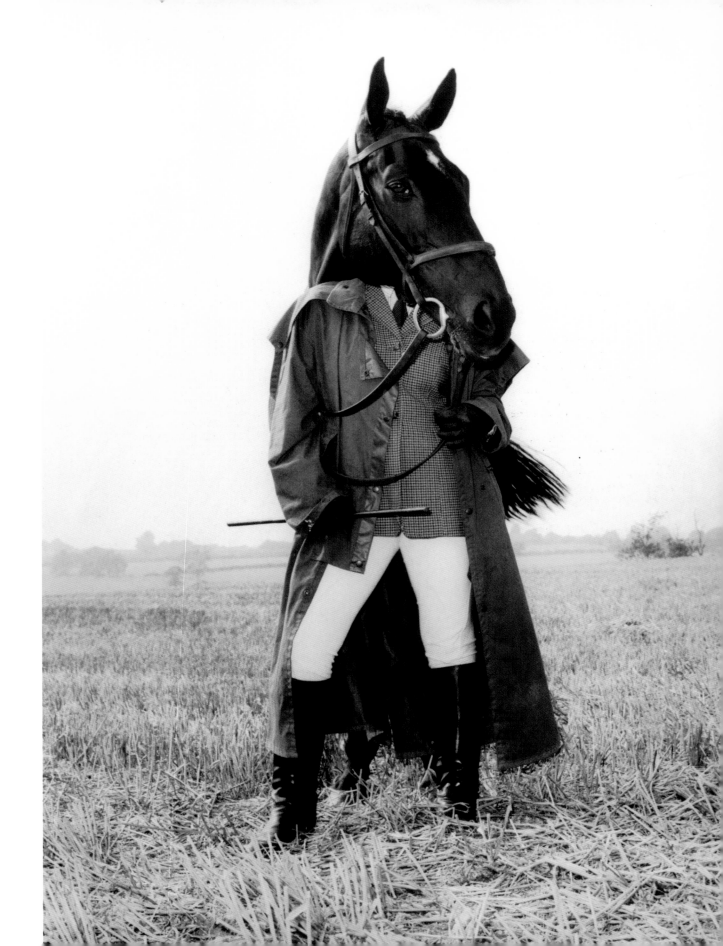

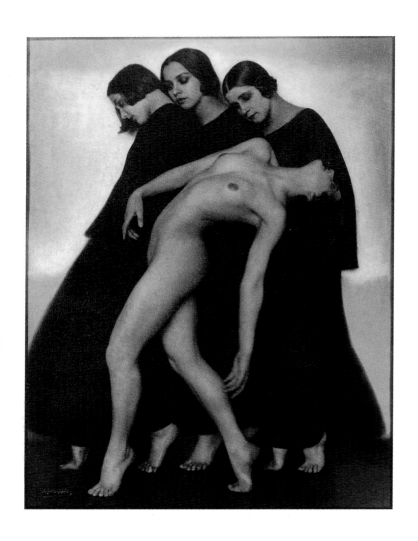

Composition

In Austria in the years between the world wars, Rudolf Koppitz was one of the primary movers in the photographic art scene, and 'Movement Study', produced in 1926, is his finest work. The composition is immaculate, and has led to the picture being declared one of the greatest images of the 20th century. The gentle tilt of the heads of the models in the background contrast strikingly with the graceful sweep of the nude in front. Her body is framed entirely against the triangular patch of darkness that has been created by their costumes, and the flow of the picture, created by the dynamic shapes moving at odds within it, ensures that the image is brimming with astonishing vitality and life. When one looks at the degree of control the models have over their bodies here, and the grace with which they're posing, it's perhaps little surprise to learn that all four were Russian dancers.

The picture resulted from Koppitz's determination to push back the boundaries of what was acceptable in terms of perspective and the use of symbolism, and his contemporaries often saw the naked figure in this picture as representing death, although Koppitz himself never added any subtitle. Whatever the interpretation, the picture certainly succeeded in changing the perception photographers had until that time of their ability to show movement in a still picture and, as such, it freed up ideas about composition and posing and still has much to teach the photographer today.

Picture: Rudolf Koppitz/RPS

Pointer Koppitz was concerned only with getting the appearance of his pictures exactly right, and he was using image manipulation to a huge extent long before computers ever arrived on the scene. His wife had the task of carrying out the retouching, which was done on the back of the glass plate, and she actually drew in one of the feet in this scene to help achieve the balance that Koppitz was convinced he needed. Such an alteration would be looked on in horror by some of today's top fine art photographers, but it didn't prevent a copy of this picture going at auction in 1995 for $100,000. It goes to prove that it is possible, perhaps, to be too precious about how the final image is achieved, when it's the impact of that image that should be the primary concern.

Printing and Processing The picture was produced as a carbon print, a process that came into use after 1864. A thin paper is coated with gelatine, potassium bichromate and a coloured pigment. After contact with the negative and exposure to light (to harden the gelatine) the carbon paper is squeezed, carbon side down, against another sheet of paper coated with gelatine. At this point the backing paper and the unhardened gelatine is washed away to leave the carbon image transferred onto the second sheet of paper. A final wash in water containing alum further sets the gelatine and results in a print that is laterally reversed and may even have a raised surface in areas where tones are dark, giving a three-dimensional effect.

Composition

Micky Mantis by Eric Howard
Hasselblad 500C, 80mm, Agfapan 100 film.
Exposure 1/4sec at f/8

I took this picture in 1990 during a period when I was playing around with angles. I was taking the camera and turning it wildly so that nothing in the picture would look right: there would be no straight lines, no square edges and the viewer wouldn't be able to tell if the camera was falling back or going forwards. I was breaking every conventional rule of composition, but I loved the results I could get by this method. It was extremely disorientating, and therefore capable of posing interesting questions: the name of the game was experimentation, and even I didn't know when I started out where each session I was undertaking would lead me.

My studio is the front room of my house in a small Dorset town, which has fairly generous dimensions: it's twenty-five feet long, twenty feet wide and has a ten-foot ceiling height. It's a good space within which to work, and I like to keep things as natural as possible when I work there. Here, by mounting my camera on a Benbo tripod that's been raised to a height of around eight feet, I've been able to look down on my model and to use the polished floorboards as a backdrop. This had the extra advantage of allowing me to include more lines in my composition and to confuse the angles still more.

My models are very often non-professionals who live locally. This is Micky, the daughter of the owner of the local off-licence, who I've used quite regularly. I'm an avid collector and visit auctions to look for odd items that I think might one day make useful props. I buy things like tiger's skulls, sculptures and carved wooden objects: this was a turtle shell I happened to find somewhere. I asked Micky to play around with it, and when she held it over her head I was struck by the way the two marks at the front of it looked like eyes, and turned her into something that looked like a praying mantis. Hence the title of the picture.

Lighting was natural too, streaming in from my front window, the reflection of which you can see in the shell. It's a very simple picture in many ways, but one I still think is effective.

Eric Howard

Printing I wanted a subtle tone here, and so I made a nice rich black-and-white print and then gave it a very quick dip in the bleach bath as the first stage of making a sepia print. Then, while it still had plenty of tone left, I placed it in the second solution, which ensured that the shades that were achieved were very dark brown. The print itself wasn't straightforward to make, because the back of the shell was so dark that it was blending into the floor. To save this I had to hold back on the printing in this part of the picture, and the method I used was to make a mask by producing a scrap print and cutting out the shell from this. Then I mounted this on a piece of wire with a scrap of sticky tape, and used it to dodge the area of the shell for a few seconds during exposure. By moving this continuously I ensured that no sharp edges were created, while the shell itself was lightened to the degree I wanted.

My favourite tip It all sounds a little philosophical, but I consider that the longer a lens is open the more magic it's capable of capturing. That's why I love long exposures, such as this one: in my opinion you're capturing more of life itself simply because your film is exposed to more of it.

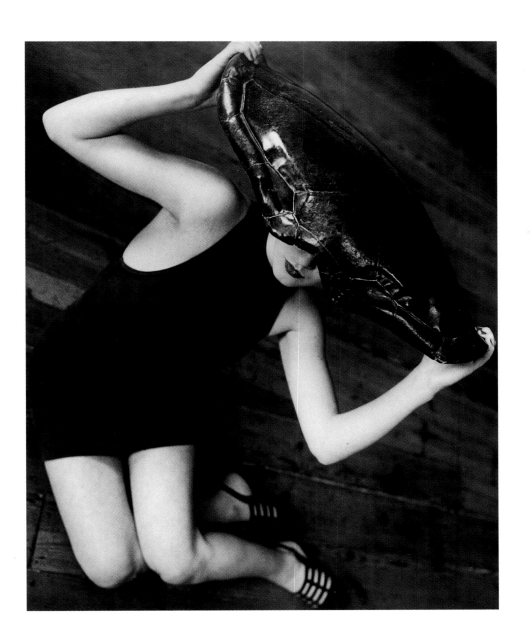

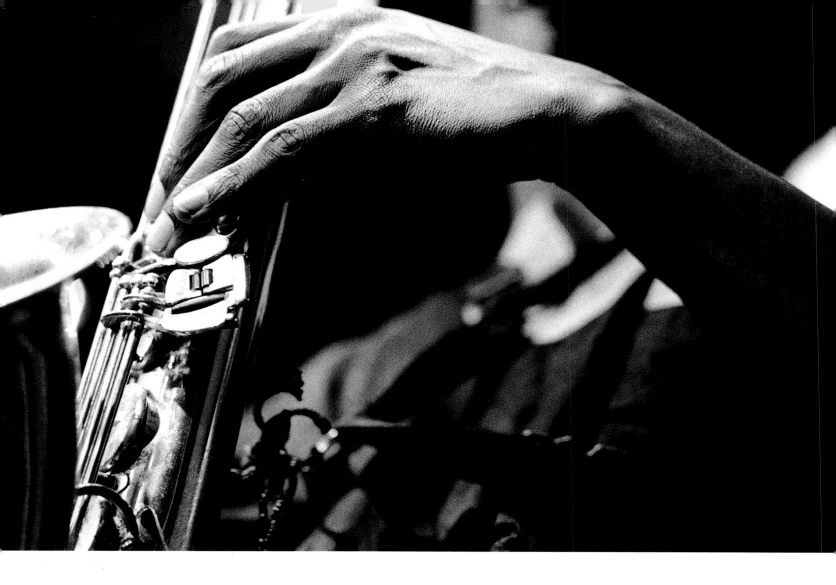

Composition

Ben Belinga by Andreas Zacharatos
Leica R4, 135mm lens, Neopan 1600 film.
Exposure 1/30sec at f/2.8

To produce a good representation of someone, particularly a performer, it's not always necessary to include the whole person in the picture. This is my interpretation of the jazz musician Ben Belinga, caught while in the middle of performing a solo at a concert I was covering. The gentle and graceful curve of the hand as it rests on the saxophone speaks volumes about the man's sublime skills as a saxophonist, and really there was nothing else that needed to be added on this occasion.

I don't like cropping my pictures at the printing stage, and in my view the whole essence of a picture is that you get it right at the moment you press the shutter. On this occasion I knew what I wanted to achieve. By using a telephoto lens, picking out the detail that interested me and then waiting for the right moment to press the shutter, I was able to come up with the study I was after in-camera and no subsequent cropping was necessary. The quality of the Leitz lenses is legendary, and this was important because the sharp detail that this enabled me to pick out on Belinga's hand was essential for the picture to work.

The final element of this picture was the contrast. I wanted my print to have rich blacks and bright highlights because, to me, this is the essence of what jazz music is all about. The lights of a concert make the event one of high contrasts, and I wanted this to be reflected in my final picture.

Andreas Zacharatos

'I don't like cropping my pictures at the printing stage: in my view, the whole essence of a picture is that you get it right at the moment you press the shutter.'

Technique Lighting at a live concert can be very difficult to meter. It will often be extremely contrasty, leading to deep impenetrable shadows and bright garish highlights. A reading taken in the conventional way could be fooled by this into indicating massive over- or underexposure, but a spot meter reading, which gathers information selectively from three to four areas of the scene, allows an exposure to be selected that is a good compromise. If there's not time to go through the complexities of working out the exposure using the spot meter method, the next best thing is to bracket. Using the camera's exposure meter as a guide, take a picture at the recommended setting and then shoot a stop either side. It's heavy on the film, but it should ensure that you get some usable pictures from the situation.

Pointer Modern black-and-white film offers extraordinary quality and opens up a whole new range of hand-holding options. The ISO 1600 film used by Andreas is available off the shelf and, printed at a reasonable enlargement, say 10x8in, offers almost undetectable grain. It allowed a shutter speed of 1/30sec to be set in theatre lighting which, even with a 135mm lens, made hand holding feasible, and the whole job of covering the concert much more manageable.

Composition

Couple at Ostend by Adrian Ensor
Rolleiflex 6x6cm, 75mm, Ilford HP5.
Exposure 1/125sec at f/16

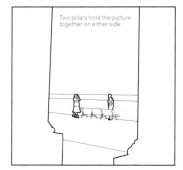

Two pillars hold the picture together on either side

Finding a dynamic natural frame can be the key to a successful composition. I came across this scene while I was in the Belgian seaside town of Ostend and, looking back through my contact prints I've discovered that this is the only negative I have that shows this couple.

I had been photographing reflections of beach huts in the windows that were behind these colonnades on the seafront and this particular picture was something that I just happened across as I turned around. I had time only to take a quick picture so there wasn't a great deal of thought process behind it, but there's still much here that I feel has worked. Though I've printed the colonnades down so that they have recorded as a solid black, the graceful shapes of their bases still reveal them for what they are. Together they hold in the sides of the picture and pull the composition together. The positioning of the couple and the poses they've taken up conveys the story of the moment, and it's all quite timeless because there's nothing in the scene to give it a positive date. In fact it has quite a period feel, and even the clothes the couple are wearing help to add to this.

Normally I try to print my whole negative, but here I've tightened the overall composition up at the printing stage by cropping in on the right- and left-hand sides, to give a little more emphasis to the scene in the middle and to even up the colonnades.

Adrian Ensor

Candids The project I had set myself in Ostend involved me taking a series of candids centred around the beach area. Some were planned, others – like this one – were spur-of-the-moment pictures, that I just happened to see.

One of the techniques I used regularly involved me finding a strong composition in an area that was a regular thoroughfare, and then waiting for someone to step into it. It's still very much candid photography, but it's a little more planned, and you have the chance this way to consider what you're doing a little more.

Throughout the whole project I set up only one portrait, of a man walking his dog. I think candids give you the chance to catch a more natural moment, and the photographer takes on the role of observer rather than orchestrator.

Composition

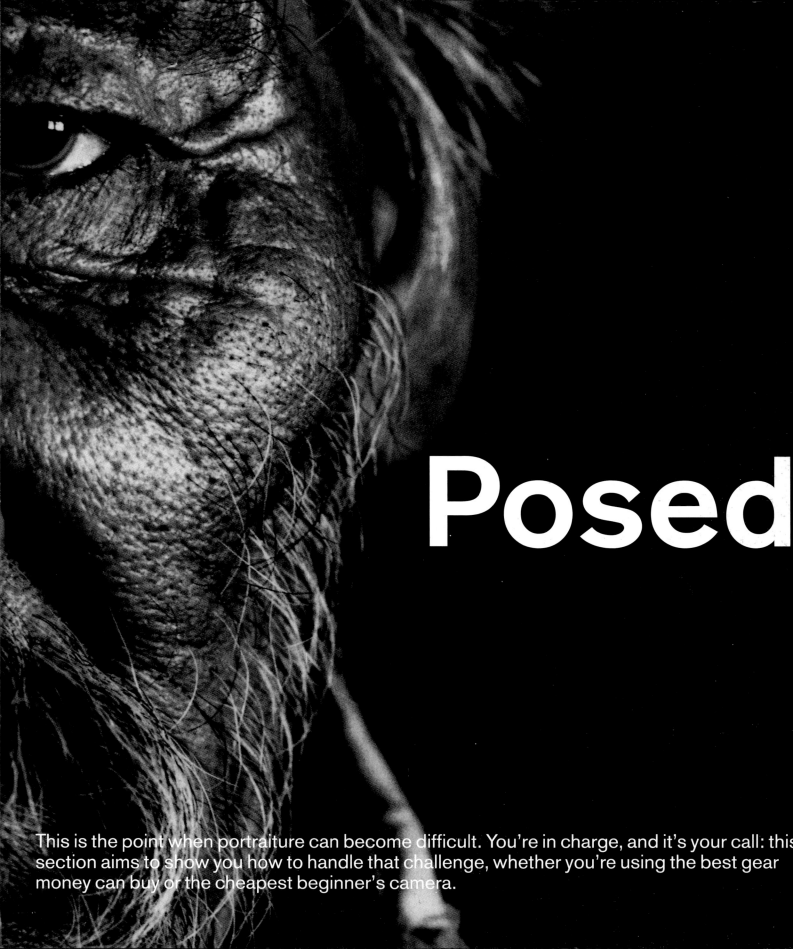

Posed

This is the point when portraiture can become difficult. You're in charge, and it's your call: this section aims to show you how to handle that challenge, whether you're using the best gear money can buy or the cheapest beginner's camera.

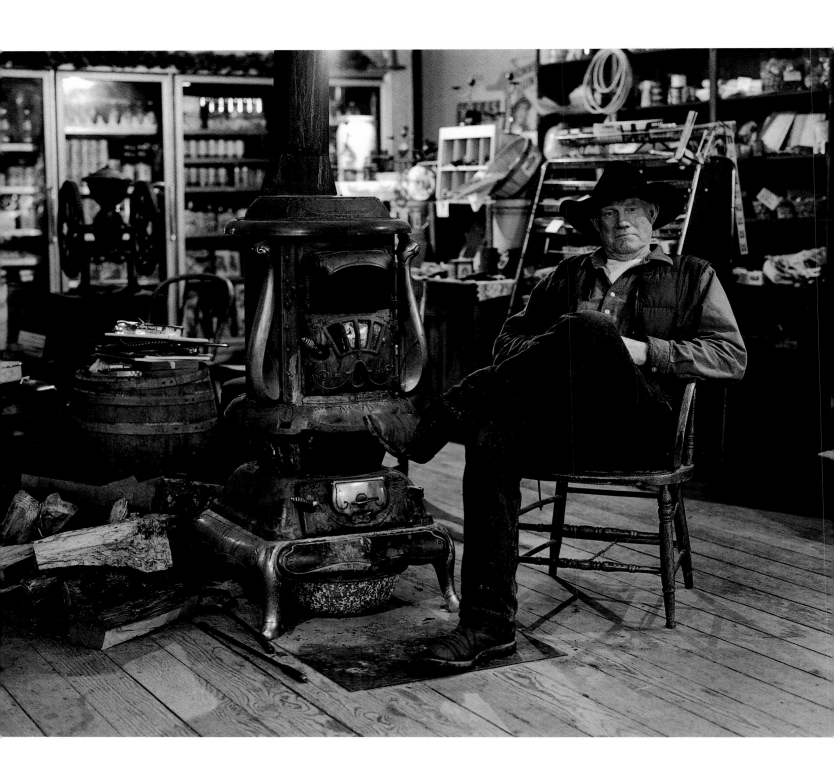

Posed

Jim in the General Store by Ron Bambridge
Mamiya RZ 67, 65mm lens, Ilford HP5 film.
Exposure 1/8sec at f/8

I came across this wonderful old General Store in a place called Fiddletown, which was located just east of San Francisco. The moment I walked in I was struck by the way it looked just how it must have done 100 years ago when it first opened, and I was determined to come away with a picture that summed up the way it had kept its identity over all these years.

I knew the picture had to have some human interest, and I asked the woman who ran the place if she would pose for me. She declined, but added enigmatically that she 'thought Jim would'. Jim, who obviously was a regular, appeared at that very moment, and I took one look at him and knew that he would be perfect. There was nothing about him to date the picture to the late twentieth century, and he just fitted his surroundings perfectly.

I like to let people pose as naturally as possible, and I'll encourage them to do something that they feel comfortable with and which isn't contrived. My luck was in with Jim: he turned out to be a natural, which made my job a lot easier. I decided that the wonderful old stove in the middle of the store, which obviously in the winter was the hub of the place in any case, should be the focal point of the picture. A chair that was kept nearby was then borrowed and brought up to the stove and I asked Jim to sit in this and to relax. He instinctively crossed his legs as I assume he always does when he sits down in that particular chair, and the picture was made.

When things don't work out, however, it's up to the photographer to take control and to direct from the camera position, taking care particularly with things like hands to ensure that they don't look awkward. You also need to encourage a subject not to adopt an expression that is the one they assume you might be after.

Remember that you're not trying to achieve a picture that looks like a candid. This photograph is obviously posed, with the subject well aware of the camera, but because nothing has been too blatantly arranged it still has a natural feel to it.

Ron Bambridge

Pointer While concentrating on getting the pose right, you have to take great care that you don't forget about the background. This was a particular risk on this occasion when the location was by its very nature cluttered, and this could have proved extremely distracting. Ron solved the problem by positioning his subject carefully so that his head was framed entirely by an area of shelving that didn't battle for attention.

Composition Ron wanted the main elements in this picture, his subject Jim and the wonderful iron stove, to have equal prominence, and so he arranged the composition so that they were in a line across the centre of the picture. Bringing the subject forward or even moving him further back in the arrangement would have created a different emphasis.

'I like people to pose as naturally as possible, and I'll encourage them to do something that they feel comfortable with.'

Posed

Blackpool Girls by Bert Hardy
Kodak Box Brownie, fixed lens, 620 film.
Exposure 1/40sec at f/11

This **Picture Post** classic from 1951 by renowned photographer Bert Hardy has become one of the most famous posed portraits of all time, and yet it was taken as an exercise to show how even the most basic of cameras could still, in the right hands, deliver great pictures. Bert's quote to accompany this story was 'it's the cameraman not the camera that wins the prizes,' a philosophy that still holds good today. The simple approach can often be the best one, and technical perfection is usually secondary to the spirit that the photographer manages to capture in that instant that the shutter is released.

Amid a blaze of publicity Bert spent three hours walking along a four-mile stretch of Blackpool's seafront, taking pictures of the people that he came across. He adapted his camera – one of the most basic snapshot models available at that time – by taping a home-made cardboard viewfinder on top to allow fast framing, but otherwise used standard equipment.

This particular picture is one of a sequence that Bert set up using model girls who were appearing in a show on the pier. The build up to this moment can be traced through the contact prints: this is the only frame on the film where all the elements have combined perfectly.

The expression of the girl on the right still sums up the timeless joy and exuberance of youth fifty years after it was taken, while the surroundings have evoked memories of sunny and carefree holidays to generations of people all around the world. The flighty and opportune billowing of the skirt is the final ingredient: a touch of glamour that raised the spirits of a country still suffering the after effects of a traumatic war.

Picture: Bert Hardy/Hulton Getty

My favourite tip It's a useful exercise from time to time to step back from the highly technical cameras that are universally available today and to take a set of pictures using the most basic equipment available today. Single-use cameras – which are essentially a 'film with lens' – are ideal, and some models are available that are loaded with black-and-white film. Suddenly you'll be rediscovering the basics of the craft: there will be no temptation to switch lenses or to play around with metering modes or autofocus. This is point and shoot photography pure and simple and, as Bert Hardy proved so effectively all those years ago, if you have an eye for a picture you should still be able to produce something worthwhile.

Pointer It's rare that anything that happens in a professional photographer's picture can be simply put down to good luck. Here the picture has been made by the wind catching the skirt of the girl to show a shapely leg, and the voyeuristic nature of this image ensures its enduring sexiness even though there probably were several girls on the beach behind at the time who were revealing just as much while sunbathing. Bert Hardy's contact strip shows that this moment wasn't entirely accidental: in virtually all the frames before and after this one, the skirt of the girls are lifting as the wind catches them. This is the one where everything gels, but Bert took a selection to try to give him the best chance of that happening. In short, an astute photographer saw the potential in the scene and contrived the accident, and sometimes that degree of planning is all that's required to turn an ordinary portrait into a classic one.

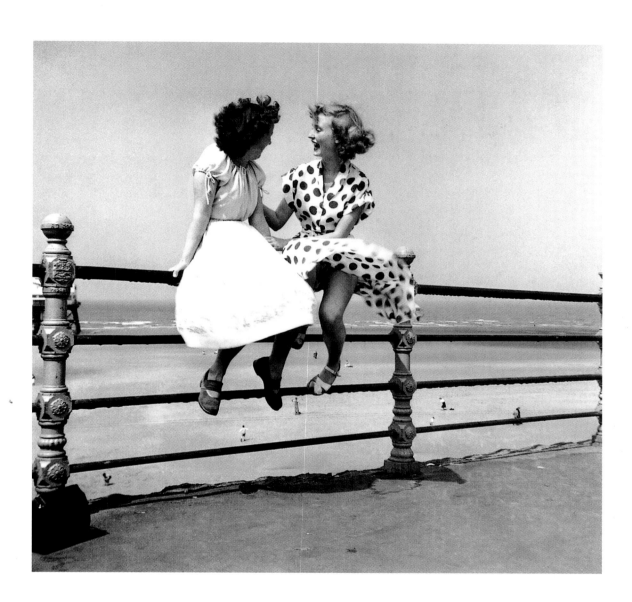

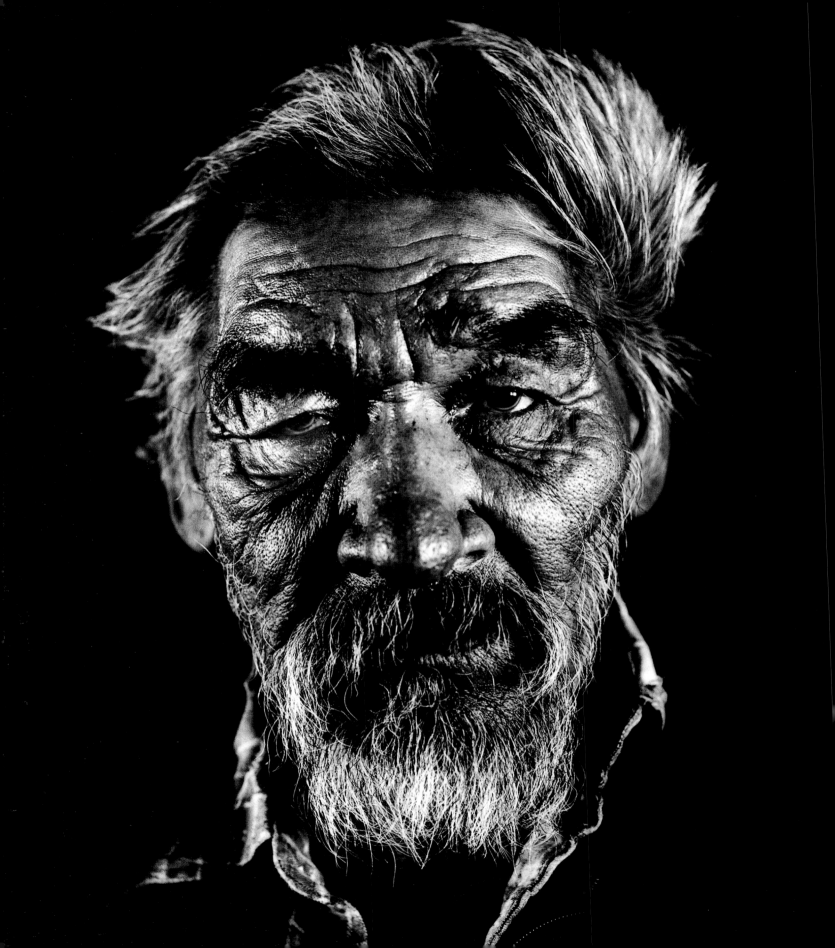

Posed

Canadian Inuk by Adam Hinton
Mamiya 6x6cm, 75mm lens with close-up attachment,
Fujifilm Neopan uprated two stops to ISO 1600.
Exposure 1/30sec at f/3.5

This is Tom Rich, a Canadian Inuk, photographed in his home, which is a log cabin near Davis Inlet in the State of Labrador. I rarely use artificial light, and here I positioned my subject next to a window where I knew the light streaming in from the left would be balanced in part by natural light coming from the other side. The picture was as simple as that: because the wood behind him was dark and there was no other area of light in the room, I knew that the background would disappear completely, and this has allowed attention to be focused more closely on him. As always, I hand held my camera and for this portrait I fitted a close-up attachment to ensure that I could frame his face tightly. This created a very narrow depth of field – you can see that the tip of his nose is starting to lose focus – but enough of his face is pin sharp to ensure that the picture works.

I was in this area pursuing a project on the Inuit for a charity that was concerned with the rights of indigenous peoples, and they had fixed me up to stay with a family while I was taking my pictures. I found it a rather depressing assignment: the Inuit had moved from being a nomadic people some twenty years or so previously to being forced to live a westernised lifestyle in fixed accommodation, and it had affected them terribly. There was massive unemployment in the area and now, instead of spending their lives hunting, the Inuit were watching TV and suffering from such afflictions as alcoholism and a high suicide rate.

It's as though their soul has been taken away, and in many ways the sad eyes of Tom Rich sum up everything that's gone wrong for them.

Adam Hinton

Pointer Because I'm moving around so much, I always travel light and I carry everything I need in one bag. My normal kit consists of three Leica 35mm bodies, five assorted Leica lenses, a Mamiya 6x6cm and 75mm (standard) and 50mm lenses to go with this. I also carry a light meter and a small flashgun. Using such a small kit for long assignments creates a useful discipline: because I haven't got lots of choices to make I find I have to adapt and that often results in something more interesting coming out of the assignment.

Technique Hard side lighting will create greater contrast and highlight the texture of a weather-beaten face, and will also pick out more detail in such things as hair. Try to include a small highlight in the eye, however, otherwise this vital part of the face can become dark and lifeless.

Posed

Eddie Izzard by Eamonn McCabe
Hasselblad 6x6cm, 80mm f/2.8, Tri−X film uprated one stop to ISO 800.
Exposure 1/30sec at f/4

I knew that photographing comedian Eddie Izzard wasn't going to be an easy job. Usually I like to make use of the available light that a location might offer, but the shoot was booked for 6pm on a winter's night in London's Soho, and I knew that I was going to have to provide the lighting on this occasion. Worse still, when I arrived Eddie was wearing a black leather jacket that would attract the shadows while, with a flight to the US booked for early the following morning, he wasn't really in the mood to give me anything as a photographer.

Faced with my usual ten minutes in which to make something work, I was struck immediately by his appearance. The beard and the jacket were part of a new look for him, and so at least I had something to work on. I quickly decided that, since he was a theatrical person, I could get away with a spot of theatrical lighting. This meant placing my one light at a low angle and directing it up at him, taking care to get a highlight in his eyes. The angle of the light also threw a little illumination on the background, and − fortunately − reflected from his coat to create a touch of highlight here. I didn't even notice this at the time: I was concentrating on his face, because whatever else happened in the picture, this was the area that had to work.

I never got a rapport going during the shoot, but I managed to come away with a portrait that my newspaper liked and used. Maybe Izzard does look a little fed up in the picture, but I've had people who have smiled through the entire session and, believe me, that's worse.

Eamonn McCabe

'Faced with my usual ten minutes in which to make something work, I was struck immediately by his appearance.'

Pointer The light was pretty poor in the room, but I try wherever possible not to shoot at maximum aperture, but at a stop down from this point, in this case f/4. That's because it's vital to get the eyes in tight focus, and you have less chance of managing that if you open the aperture up completely. In this case it meant that I found myself shooting at 1/30sec but I was using a tripod and so I could keep the camera still for that time while I figured that Eddie, with his theatrical training, would have no problem keeping still himself for that duration.

My favourite tip The light I always take along if I need a little extra help is a common household angle-poise lamp. This is flexible and manoeuvrable in use and easy to carry, and the beauty of using this in combination with black-and-white film is that you don't have to worry about colour temperature and the cast that tungsten lighting might cause. Unlike flash, my lamp also lets me see what I'm going to get, and I had a good idea of how the lighting arrangement here was going to work out before I ever pressed the shutter.

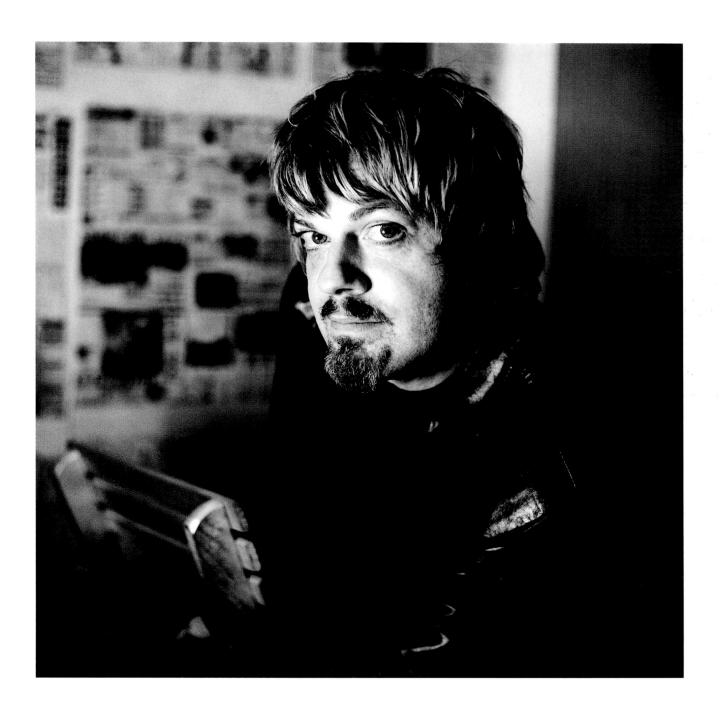

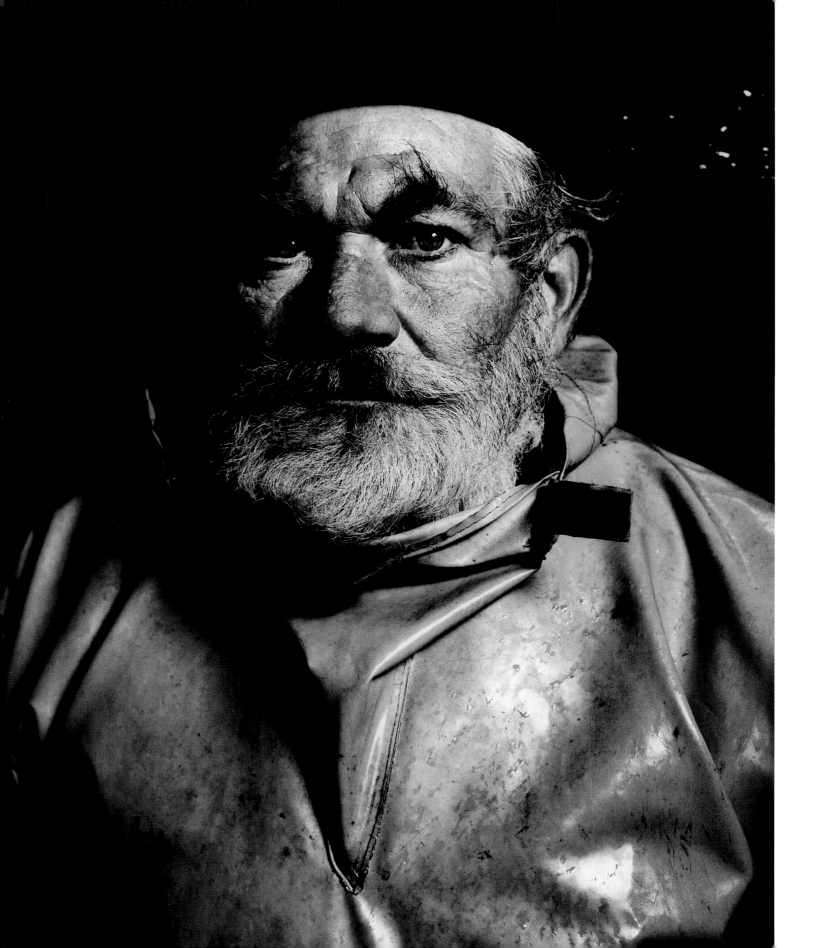

Posed

Welsh Fisherman by John Claridge
Ebony 5x4in studio camera, 210mm standard lens, Agfa 100 film.
Exposure 1/60sec at f/22

I'd been to see this fisherman the day before I was planning to take his picture and made an arrangement to meet him as his trawler came back from a night's fishing. I wanted to photograph him in his environment, and to capture him the moment he stepped off the trawler, while he was still cold, wet and tired from his exertions, and before he had time to think about how he might want to present himself to the camera.

In order to produce an image that was as natural as possible, and which caught the essence of his character, it was important to keep things simple and not to impose on him either the camera or myself. Accordingly I set up just the one light, which I kept low and from one side, and I gave him the minimum of direction and allowed him to take up a position he felt comfortable in. The single light had the advantage that it picked out the texture of the man's beard, his most striking feature, and also produced a highlight in each eye to add a necessary sparkle there.

I didn't talk to him about the picture I wanted for the simple reason that I didn't know myself exactly what I was after: with a picture such as this there's always an element of the unexpected, and that's part of the excitement of taking on portraiture of this kind. You make the most of the situation you find, and if you're lucky everything will fall into place and you'll come away with something that's really special.

John Claridge

Technique One of the chief advantages of using black-and-white film for portraiture is that it helps to remove the distraction of colour, and takes the picture down to a simple series of tones. Here it's helped to bring out the detail of the subject's beard while accentuating the texture of his weather-beaten skin. It's also ensured that nothing jars or disturbs the overall flow of the picture, which in turn means that the piercing eyes of the subject have been allowed to dominate here. In colour, the bright yellow of the man's sou'wester took the attention because of its vivid hue, and consequently it lessened the impact of the portrait.

Pointer A switch of format can often have a major effect on the kind of picture that's achieved. The formality of the studio camera, and its size, enforces a more considered method of working, and John Claridge used the format for this portrait because he wanted to test his own discipline. The use of a 35mm camera would have given a quite different look to the picture, allowing more room for an instinctive approach, and an altogether more relaxed result.

Posed

Posed

Chet Baker by John Claridge
Mamiya RZ67, 140mm lens, Agfa 100.
Exposure 1/125sec at f/16

Posing is something that should come naturally, you shouldn't need to work too hard to get someone into the position that you want them in. And this was the way it was, when I got the chance to photograph the great jazz musician Chet Baker. The picture was set up in a matter of moments, and I tried not to interfere but to leave things very much as I saw them. Even the fact that there was a tiny part of Chet Baker's trumpet visible in the picture, something that helped to place him and who he was, was just one of those things. It happened, I didn't arrange it.

My studio at that time was above Ronnie Scott's jazz club in London's Soho, and being brought up on jazz I was in my element. Sometimes I would ask the performer who was appearing that night if they would agree to come and sit for a quick portrait, and the Chet Baker session was one of those times. I told him that his was the first jazz album I'd ever heard, and that his Winter Wonderland record was one of the first I'd bought as a kid of thirteen. Then there was this silence and I had the feeling that perhaps he was thinking back to his earlier days. And that was it, I just took the picture.

For me it's a very haunting portrait, not because I took it but because of what it means to me. I think the picture has more depth than any other picture I've ever taken, and my assistant that night told me later that he couldn't believe the atmosphere there was in the studio while the picture was being taken.

Despite the fact that he meant so much to me as a person, it wasn't an intimidating experience to photograph him. Just the opposite in fact: it's one of the things that photography allows you to do, to communicate with someone on many levels. And when something happens, as I feel it has here, it's just magic and I don't think there's any analysis for that. That's why we try to take pictures, and sometimes we get it right.

John Claridge

Technique The picture was taken using just one Balcar light to the left of the subject, and with no reflector to bounce light back onto the right of the face – that part of the picture has been left in fairly deep shadow. The mood that this has created, however, is entirely intentional and quite striking. Portraiture is not about providing technically perfect lighting arrangements for every situation, it's more about creating an atmosphere that suits a particular subject, and often it's the part of the face that's not seen in complete detail that makes the picture. The angle of the light here has allowed strong modelling to be created on the face, while a tiny, and essential, highlight has been picked out in each eye.

Pointer The longer it takes to set up a picture and to sort out the technicalities, the less chance there is of allowing your sitter to relax and to give you something special. Even if you intend to set up a complicated lighting arrangement, it's vital to plan things in advance so that there is the minimum of delay once the sitter arrives. With portraiture it's always the spirit that's captured in the picture rather than the technical expertise that's gone into it that determines whether the picture is a success or failure.

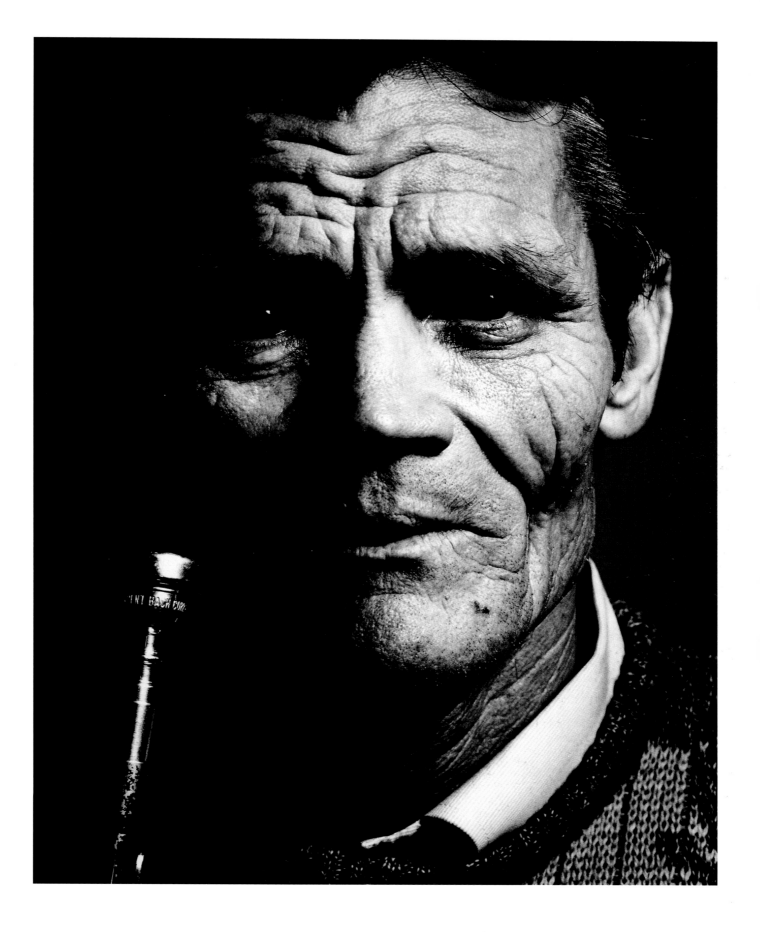

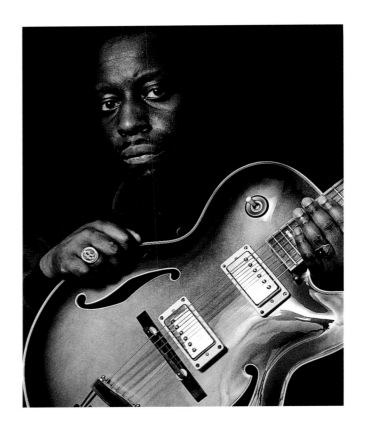

Posed

Ronny Jordan by Gary Wilson
Canon F1, 135mm, Kodak Tri–X.
Exposure 1/90sec (flash synch speed) at f/8

I had an assignment to photograph British jazz guitarist Ronny Jordan in the recording studio where he was working, and there was no opportunity to set up anything that was too contrived. When he took a quick break, however, I grabbed the opportunity to sit him down with his guitar on a sofa in the lounge area, and I managed to take this portrait of him. The set-up was very straightforward. I always carry a minimalist lighting kit with me, which consists of a flashgun and stand, and a small brolly – so called because it has the appearance of a highly-reflective umbrella – that attaches to the front of the flash to bounce light back onto the scene. Everything is designed to be very quick and easy to set up: the stand opens out to reach five feet in height, but folds down to just eight or nine inches, and so it tucks neatly into my gadget bag along with the rest of the kit. With the stand set up behind me, I connected the flash directly to my camera with a synch lead, and then adjusted its position until it sat behind my left shoulder so that it would illuminate him just to the left of head on. Although the light was bounced from the brolly, it was still quite hard when it reached him, which was the effect I wanted. The picture was set up and taken in a matter of minutes, and yet my simple lighting arrangement has given it the appearance of a far more formal studio set-up.

Gary Wilson

Printing and Processing The straight picture featured quite a messy background, with pictures on the wall and some African masks that were picking up rather ugly highlights from the flashgun. I got round the problem however by giving the area around Ronny's head a substantial amount of extra exposure at the printing stage to darken this area right down, a process known as burning in. It's a technique that works particularly well when the subject, like Jordan, has dark skin, because the shadows you've created blend subtly into the face, and the effect isn't too pronounced. To finish this picture I toned it in Agfa Viradon for five minutes. This is a one-bath toner with no bleach stage: you simply leave your print in the toner until it reaches the required density of colour and then wash to finish the process.

Pointer With a musician, it's quite a good idea to use their instrument as a prop. Ronny had been carrying his guitar around all day, and I asked him if he would pose with it for me. As he sat down in what was quite a low sofa, it was natural for him to hold it up at this height at an angle, and so the picture just fell into place. The other prop I made use of was his trademark 'R' initial ring. By being aware that this was an important element of the picture, I was able to get him to position his hand so that this featured prominently in the picture.

Posed

Rock Face by John Swannell
6x7 camera, 135mm lens, Agfa APX ISO 25 film.
Exposure 1/30sec (flash synch speed) at f/22

Julienne, the model I was using here, has a body that is probably as near to perfect as it's possible to get, and I wanted to use her for a picture that I had in mind that was heavily influenced by the work of the surreal painter René Magritte. He painted a portrait of a man with an apple in front of his face, and I thought I could play around with that idea to produce a nude study with a rock covering the girl's face.

The problem of course was how to set a picture like this up without having to resort to image manipulation. The answer was for me to find and to photograph a rock that I thought would work in the image in terms of size and shape. Then I gave the picture of this to a special effects man who has worked with me on several occasions, and he was able to make an exact replica of the rock from polystyrene. This was suspended by a thread from the ceiling of the studio, at the right height to cover Julienne's face when she pressed her nose up against it. I wanted a hard light, so I lit her directly with just one flash spotlight from a high angle, and set her against a plain white background to keep the picture simple.

John Swannell

Technique Flesh tones seen against a white background can start to get lost, and so I wanted to add some shadow around my model's body to make sure that this didn't happen here. All I needed to do to create the shapes that I wanted was to place some barriers in front of the spotlight, and through careful positioning of these I was able to throw the shadow in exactly the areas where it was required.

Pointer Plain white backgrounds make one of the most effective backdrops to any black-and-white portrait, but producing them is not as easy as photographers may imagine. John Swannell learned his technique through working with David Bailey for four years. The trick is to flood the white backdrop with flashlight so that it is much brighter than the foreground, enabling it to be overexposed in the final picture so that its surface is bleached and without any tone. Some kind of balance has to be achieved, however, because if the background is too brightly lit it will start to bleed into the edges of the person seen against it.

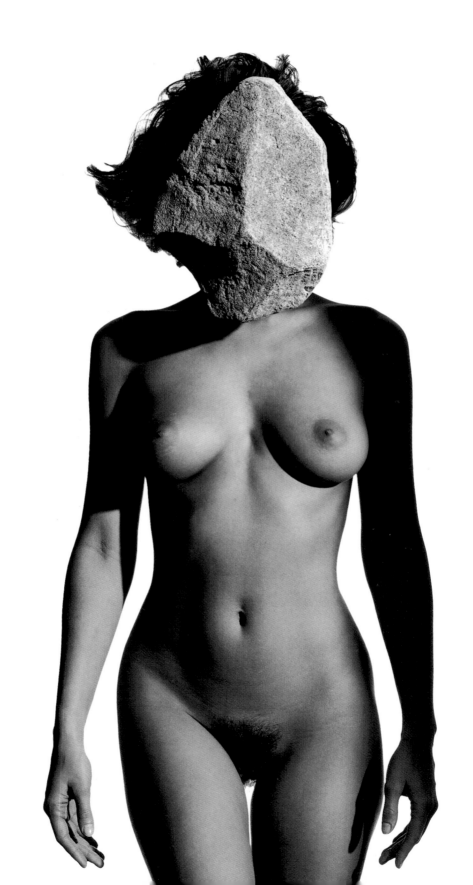

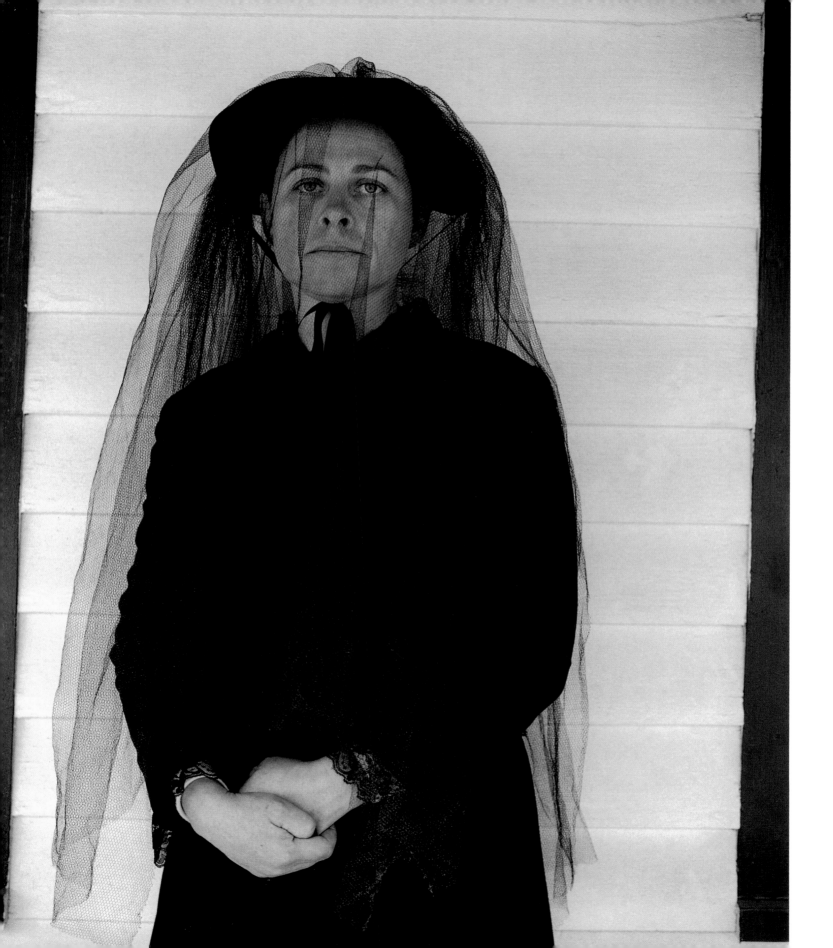

Posed

Woman in Black by Ron Bambridge
Mamiya RZ67, 180mm lens, HP5 film.
Exposure 1/30sec at f11

This woman was part of a re-enactment event taking place in the Coloma region of the western United States, an area that around a hundred years ago was the subject of one of the great American gold rushes. She had the most wonderfully expressive face, and I was immediately drawn to her and I arranged to take her picture.

The first thing I did was to ask her to move out of the direct sunlight and into the shade of a veranda. Portraits are rarely best shot in harsh and contrasty lighting conditions, and the nice soft light that I moved her to was much kinder, and easier for me to control.

My subject was wearing a veil that was fastened up around her hat, and I asked her if she would mind letting this down for the picture. She agreed, and I think the texture that this has added to the picture has worked particularly well. I posed her against a side of a wooden building to achieve some texture in the background as well, and used a slightly longer lens on my camera to allow a perspective that pulled this more into the picture.

Framing also needed to be carried out carefully. I took up a low viewpoint to allow my subject to look down at me, which gave her a stronger look, and I also included a thin slice of the window frames on either side of her to form a symmetrical shape that held the whole picture together. The pose she took up didn't require much direction from me, although I took care to see that her hands looked comfortable. The expression she gave me was amazing and suited the picture perfectly: her eyes seem to say so much, and she had great intensity. With someone in front of the camera, you find that you either get something special or you don't. I couldn't have asked her to look like this through direction: she gave me something of herself and the camera has caught the moment.

Ron Bambridge

Technique Metering for this portrait was potentially quite tricky, because the tones within the scene varied all the way from the dark clothes my subject was wearing through to the white of the background. I wanted to retain detail in both of these areas, and I knew a general meter reading would not necessarily give me the ideal exposure. I solved the problem by taking a series of spot meter readings. This is a method of taking an exposure where you can take a precise reading from just one tiny selected area, say a piece of the black clothing or the white highlights. This way you can build up a precise idea of the contrasts within the picture, and can then set an exposure that will serve as a good compromise.

My favourite tip I've always found that people are very willing to be photographed if you make a reasonable request, but it's always a useful part of your conversation to make the offer of a subsequent print. I take details of the people I photograph and make a point of ensuring that they eventually get a picture for themselves. It's good etiquette and a very persuasive ploy.

Posed

Melvyn Bragg by Eamonn McCabe
Hasselblad 6x6cm, 8omm lens, Tri—X pushed one stop to ISO 800.
Exposure 1/125sec at f/5.6

I'd finished taking my pictures of writer and broadcaster Melvyn Bragg and I was preparing to leave. Maybe it was just my journalistic instinct, however, but I still had all my kit to hand when he put his hands up to his eyes in this particular motion. I hadn't realised it was coming, and I had just a second or so to grab this unposed portrait. I considered it something of a triumph that I managed a picture that was still sharp enough for my paper to use even though circumstances dictated that it was hand-held.

It's important to be ready for spontaneous moments like this, because it will generally look contrived and awkward if you try to get the subject to repeat the action. Portrait photographers are always looking for this kind of off beat instant, because it can lift a picture and make it into something that is out of the ordinary. That can be a real bonus if the person you are photographing is a familiar face, because it can enable you to come away with something that's unique to you.

In this case it also solved the problem of what to do with the sitter's eyes. It's hard for someone to look at a picture where the subject is staring directly at him or her. It's unnerving and it's usually better if you can relax your subjects and encourage them to look more naturally into your lens. Also avoid the pose where the sitter is pointedly pretending to look in another direction: that's far too obvious a set up.

Eamonn McCabe

Pointer I take a newspaper approach to my portraiture, and invariably I'm given just ten minutes to take my pictures. In many ways that suits me, because I have a theory that the energy between you and a sitter is only really flowing for that amount of time anyway. If I were to be given three hours in a studio I wouldn't know what to do with it. Because I've got to work quickly I'll go into a situation looking immediately for what's going to work. I never preplan anything, I work with what I find. I have some flexibility, however, in that I can move someone around in a room to where the light is working. Light is the most important thing for any portrait, and there's usually a lot of natural reflection going on in a typical room that you can use to your advantage.

Technique Hands are one of the most difficult elements to manage in any portrait, and consequently some photographers like to exclude them. I like using them, however, because they can help you to achieve a more complete portrait, but they are a challenge. No two people react to their hands in the same way: someone who's a pianist or a guitar player can use their instrument as a prop or, if you're photographing a couple, it can be an option to ask them to hold hands. Some people are so natural that they'll put their hands in their pockets, or perhaps they'll clasp their hands together and that simple action can lift a picture. Explore your options and see what you're getting from someone: it's worth persevering.

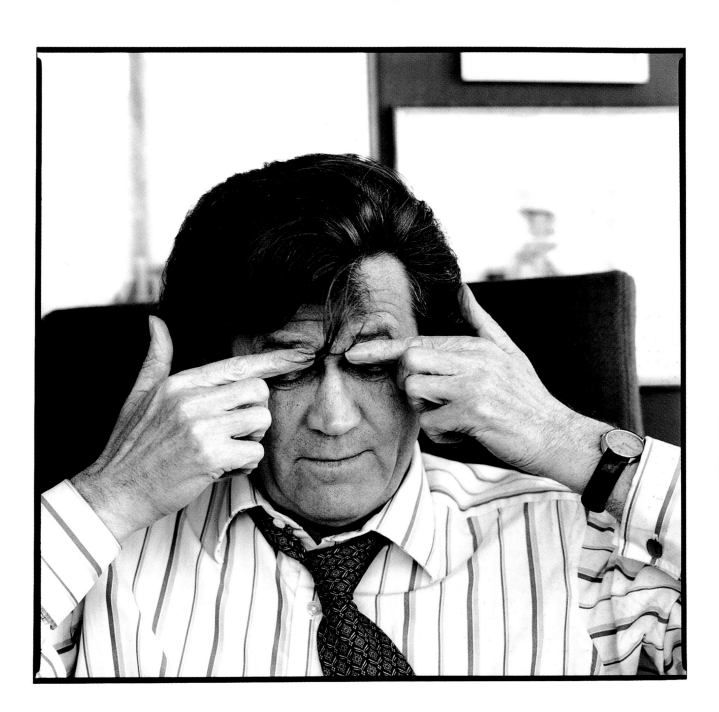

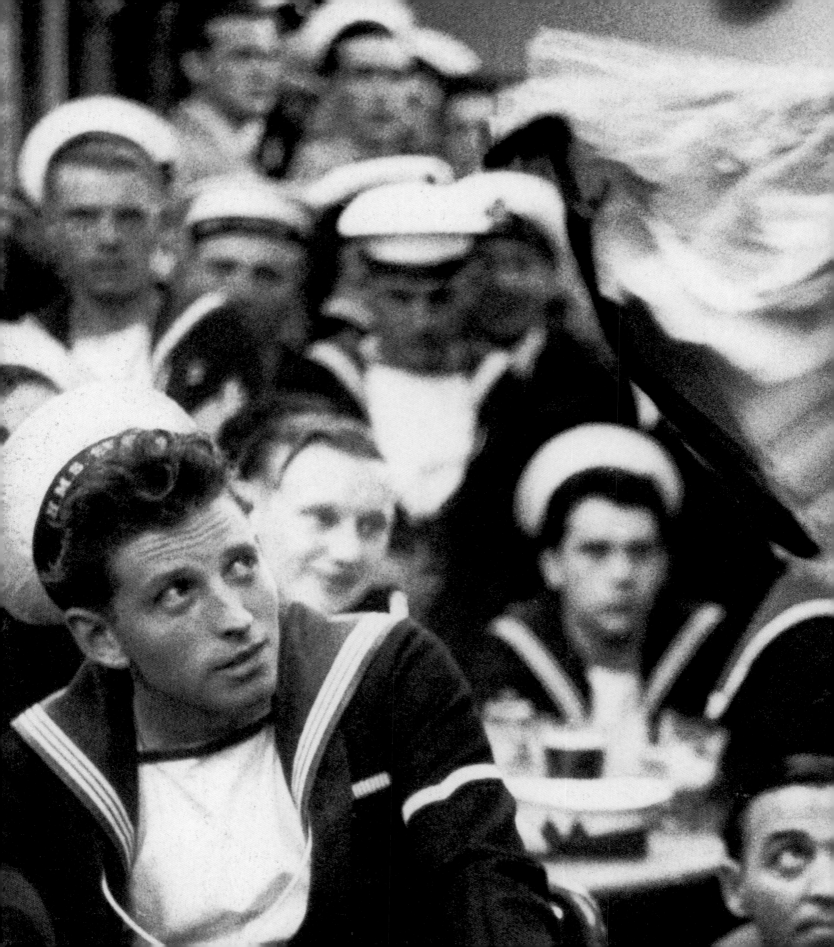

Candid

Many of the portraits we like to call classics are candid in nature. They sound easy to take: all you need is a simple camera and a touch of bravado, but if that was the case then we'd all be able to rival Cartier-Bresson. This section looks at how to get the most from the unposed portrait.

Candid

Dancing couple by Adrian Ensor
Nikkormat 35mm SLR, 35mm lens, Kodak T–Max ISO 3200 film.
Exposure 1/30sec at f/2.8

I was on a photographic journey across Ireland, and along the way I was capturing some of the experiences I had and some of the people I met. This was taken in a small bar I visited one night, where people were dancing to traditional music, and I knew this man in the picture because I'd come across him the day before when I'd gone to a ceilidh, and he got up and sung a song there.

I thought this picture of him dancing in the bar with his wife summed up the atmosphere of this particular evening very well. It was a lively and enjoyable event and everyone was having a good time. This candid moment said everything that needed to be said. It's a couple reacting with each other on the dance floor, the heavy grain of the film and the softness of the image suggests the nature of the event, while the pint of Guinness, just visible on the bar, is the final touch that puts it all in perspective.

I discovered later that the man was suffering from terminal cancer. I sent a print of this picture to his wife after he died, and she sent me back a lovely letter, and told me that I'd managed to capture a moment between them that was really special. It confirmed for me all the decisions I'd made as a photographer in terms of how I took the picture and how I printed it: the power of a picture is not in the detail it can show, but in its ability to touch people.

Adrian Ensor

Pointer Some photographers choose to present all their work uncropped, but often an image will benefit from a certain amount of tightening up at the printing stage. This picture, for example, is just a portion of a much larger image. By picking just a section of his negative to use, Adrian Ensor was able to change the emphasis of the picture and to crop to allow the Guinness on the bar to play a greater role. It also allowed him to make more of a feature of the film's grain and the almost abstract softness of the image, both elements that have contributed greatly to the atmosphere of the picture.

Printing To give his Irish series a greater sense of continuity, Adrian Ensor finished all the images within it in the same subtle shade of thiocarbamide tone. As with sepia, the toning process consists of two stages. First a print needs to be bleached and then it requires toning to bring back the strength and intensity of the image. By varying the strength of the two solutions that are mixed to make the toner, the final colour of the print can be varied between dark brown and a much lighter yellow brown. Printing dark has emphasised the mood of this picture: Adrian's philosophy is that if you print dark enough, you'll eventually see where the light is coming from. See page 118.

'The pint of Guinness, just visible on the bar, is the final touch that puts the picture in perspective.'

Candid

Gymnastics on the Beach by Eric Howard
Leica 35mm rangefinder, 28mm lens, Tri–X film.
Exposure 1/250sec at f/5.6

Most of the elements of the picture were already in place, and the key to the image was waiting for the right moment to photograph the girl. She was wearing dark clothing and she made a good contrast seen against the lighter tone of the sea: I decided that, as she seemed likely to be practising for a while, I could afford to watch for a while to see what she was doing. One particular backward arch was especially graceful, and I waited until she tried this particular move again and shot as the curve of her body was at its greatest.

It was a lovely Dorset summer Sunday afternoon in 1976 when I took this picture and the Olympics was in full flow. The British public had just seen some of the amazing young Russian gymnasts performing there for the first time, and the whole country was talking about them. As I got out of my car on this day I noticed this eleven-year-old girl, who was obviously caught up in the whole thing, going through her own personal gymnastics routine quite oblivious to anyone else. I realised immediately that the scene had the potential to make a strong candid portrait.

The kind of camera you use for candids exerts a big influence on the way you take your pictures. It's so easy with the modern point-and-shoot autofocus models to simply lift the camera up to the eye and to take a picture the instant you see it. This can be a benefit at times, of course, but my feeling is that candid photography benefits from a little more thought before the shutter is pressed. If you have the chance, it's always a good thing to consider exactly how you're going to take your picture. With a rangefinder camera like the Leica, you don't have a choice: you have to take a few moments to set the exposure and to bring everything into focus. It makes you pause for a moment and in that time you can be thinking about composition and whether you're shooting from the right angle.

Eric Howard

Composition I wanted the girl to appear isolated to increase the sense that she was in a world of her own on this beach. This wasn't particularly easy, because there were plenty of people around on this particular day. I fitted the wide angle lens to allow me to approach quite close to the girl to exclude the people around us, but to still leave a good amount of foreground to give the impression that I was further away than I was. This also allowed me to give extra emphasis to the boat to the left of her, which was a vital part of the whole arrangement and an absolute godsend to me as a photographer.

Pointer When you're looking for candids, it's always easier to catch people being natural and unaware of the camera when they have their attention on something else. That's why something like a rally or a sporting event will be particularly productive, because people will be concentrating on things other than you. Look also for the unconventional angle and the different approach: as here they can pay handsome rewards.

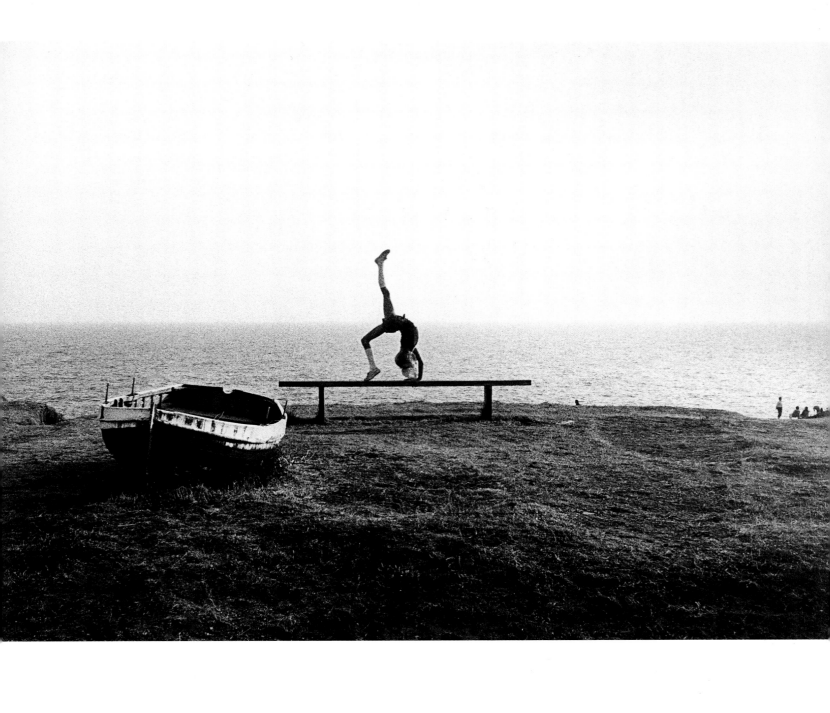

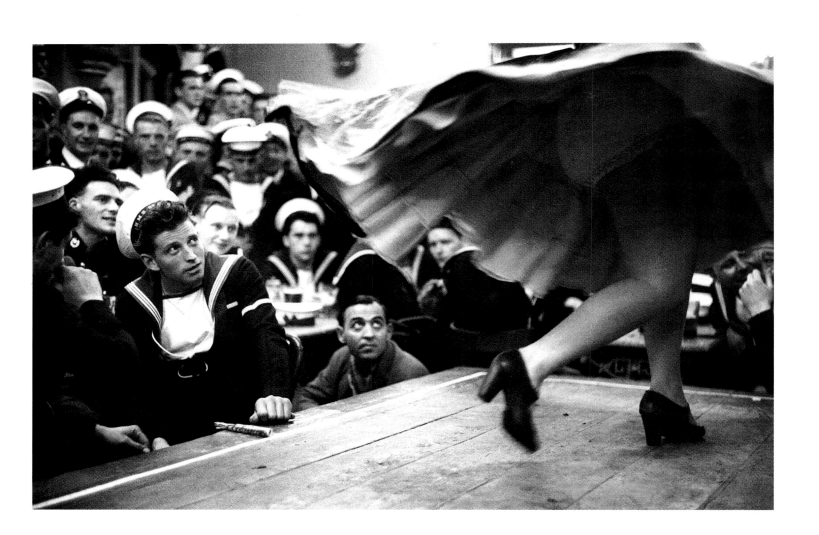

Candid

Candid pictures can stand or fall on a single expression on the face of a person in a crowd of people. Here a complete story could be written about this scene, expertly captured by **Picture Post** photographer Bert Hardy in 1954. The sailor, enjoying a spot of shore leave in Gibraltar, has visited a local bar with his shipmates, where the entertainment on offer is in the form of Spanish girls, who have crossed the border for the night to act as 'hostesses'. Hardy watched the evening unfold with his trusty Leica at the ready, and noticed that as the girls reached a certain point in their routine their dresses would fly provocatively in the air. The sailor in the front row realised the fact too, and was waiting for the moment when he would be rewarded with a quick flash of the dancer's underwear.

The rest is down to timing, and this so often is the art of successful candid photography. A second either way and the picture would have been lost, but the picture has been taken at precisely the right moment. One might suggest that there was an element of luck involved, in that the expression of the sailor was not arranged, but even this is down to anticipation not pure chance. The likelihood is that Hardy had spotted the actions of the sailor leading up to this point and had realised exactly where he would be looking at this particular stage of the routine. The result is a picture that genuinely speaks a thousand words, the kind of image that Hardy became renowned for throughout his glittering career.

Picture: Bert Hardy/Hulton Getty

Sailors on shore by Bert Hardy
Leica 35mm rangefinder camera, 50mm lens.
Film and exposure unknown

Pointer The more you practice your candid photography, the better you will become at it. A useful exercise is to visit a lively public place, say a bustling market or a rally, and to shoot a roll or two of film on some of the characters you find there. Spend the first hour or so simply observing, and seeing how people are reacting with each other. If you see an interesting face don't be tempted to rush in and snap away: be patient and wait for the moment. Great candid pictures are never down to pure chance, they have to be worked at, and you'll have a lot of failures before you start to achieve success. One further point to note: Bert Hardy used a 50mm for many of his classic pictures. It's still a great lens to use for candid photography, so don't be tempted to fit a long lens and to shoot from a distance. The best pictures are usually captured close up.

Technique It would have been very easy for a flash to be used here to freeze the action, but this would have destroyed the very atmosphere that Bert Hardy was trying to capture. Instead he utilised the light that was available, and the slow shutter speed that has resulted has positively benefited the picture by allowing the flying skirt to be blurred, emphasising its movement. The sailor, meanwhile, is concentrating on his illicit moment and has remained static enough to be registered perfectly sharp.

Candid

Candid

Boys in the Gorbals by Bert Hardy
Leica rangefinder, 50mm lens, Ilford HP3 film.
Exposure 1/125sec

This candid portrait from **Picture Post** photographer Bert Hardy was taken in 1948 for a story the magazine was running on the run-down Gorbals area of Glasgow, and yet it retains its freshness even now.

Bert was aware of the value of being ready for any situation, and his custom was to set his Leica to give him perfect focus at four yards distance. This meant that if he came across a scene such as this one, all he needed to do was to frame and fire, and he could react very quickly as a consequence.

Naturally candid photography is not quite as simple as that: Bert was the master of choosing the right moment, and this picture has become his most famous image largely because of that fact. By instinctively crouching down to the level of the boys, he's allowed them to dominate the frame, a fact that's been accentuated by their closeness to the camera position. At the last moment they've noticed the photographer and have looked across, creating vital eye contact and establishing a rapport with the camera.

Bert pressed his shutter at the moment the arm of the boy on the left cleared the lamppost, and this has allowed a fraction of space to be seen between them. A second or so earlier and the post would have cut through the boy's arm or perhaps even have appeared above his head, which would have ruined the study.

Some might imagine it was pure luck, but Bert performed the trick too often for that to be the case. His eye for a picture was unerring: the secret of great candids is this instinctive ability to be able to see the potential of a scene and to act quickly enough to capture it on film.

Picture: Bert Hardy/Hulton Getty

Technique Modern autofocus cameras are extremely fast, but there's often still that split second of delay that can ensure pictures such as this still can't be judged as accurately now as Bert Hardy did back in 1948. His technique – to set focus to a point where anything at close quarters would automatically be in focus – can still be effective today. If you can find what is known as the 'hyperfocal point' in a scene, then you'll be able to obtain maximum depth of field: this is defined as the distance between the lens and the nearest point of acceptably sharp focus when the lens is focused for infinity. When you refocus to this point, known as the hyperfocal distance, depth of field will extend from half this distance to infinity, the greatest depth of field it's possible to obtain at a given aperture. Don't forget the basic rule that the smaller the aperture the greater the depth of field, which ensures that the more you stop down the closer the hyperfocal distance will be.

Composition Bert Hardy had an automatic sense of great composition, well illustrated in this, one of his greatest pictures. The pavement and the road converge to a point in the far distance, which is just off-centre. Imagine for a moment that this point fell squarely in the centre of the picture, and you can see that the composition would have been much weaker. Just a step to the left would have diluted the picture's strength: as it is one of the golden rules of composition has been followed to the letter and the picture benefits greatly as a result.

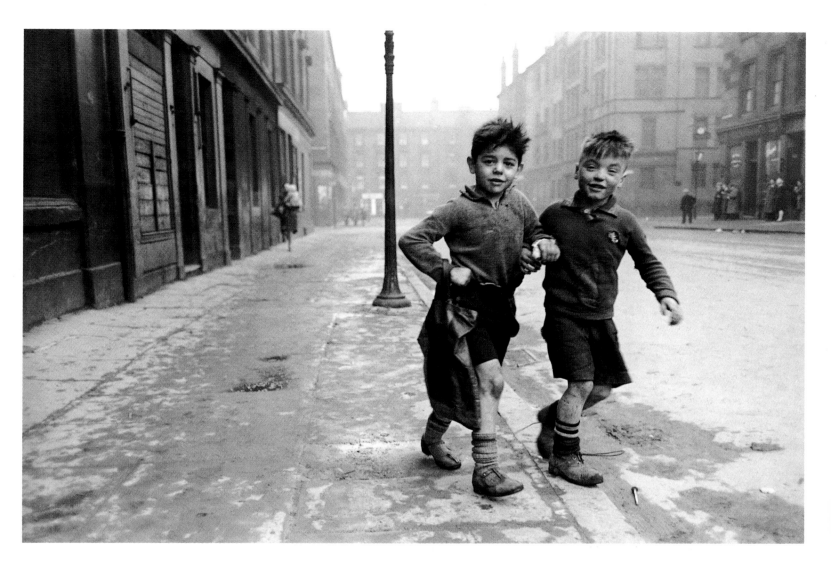

Candid

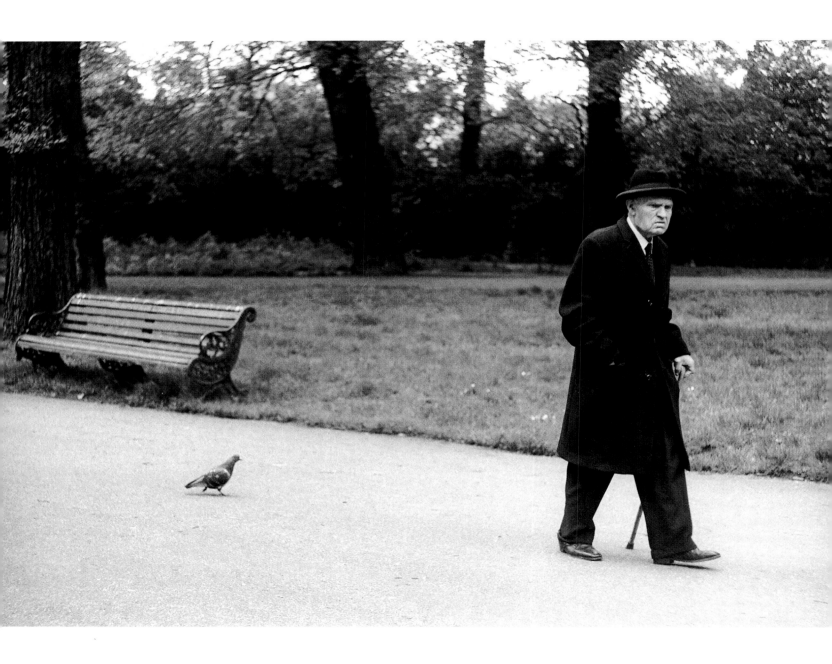

Man and Pigeon, Regent's Park by Terry Hope
Olympus OM1, 50mm, Tri—X film.
Exposure 1/250sec at f/5.6

The art of a successful candid portrait is to shoot unseen. Any eye contact between the subject and the camera can ruin everything: it takes away the spontaneity, and makes the picture look contrived.

I spotted this particular gentleman taking a stroll in Regent's Park in London one afternoon and was struck by his characterful face and the fact that he seemed oblivious to everything happening around him. It was an obvious photo opportunity, and I didn't want to alert him that I was planning to take his photograph for fear that he would be alarmed or would glare into the camera.

Fortunately I had been taking pictures before he arrived on the scene, and I had already set the exposure for this particular lighting situation. I was happy with the aperture. I knew it would allow the background to go a little soft, which I wanted because this would isolate it from the main subject. Meanwhile the shutter speed I was using was fast enough to ensure that I could pull the camera up to my eye and shoot quickly without the danger of camera shake.

What really made the picture work, however, was a little piece of luck. As the gentleman approached me I noticed a pigeon keeping pace behind him, and I decided at that instant that this was going to be the essence of the picture. The second bonus was that no one else was in the frame at the moment that I lifted the camera and fired. By leaving the necessary amount of space around my subject I was able to indulge in a spot of visual humour. One man and his pigeon out for a walk and, as a final stroke of good fortune, even their legs are in perfect harmony.

This was the only frame I was able to take, before the man and his feathered friend passed by, and I took care to shoot at the moment when he was taking a stride forward, so that the shape he made was at its most pleasing. For those who like reading things into a picture, the empty bench to the left of the picture perhaps makes a point about the isolation that old age can sometimes bring. I'd like to say I planned it that way, but I didn't: still, candid photography is often full of these lucky moments, and the more pictures you take the luckier you become.

Terry Hope

My favourite tip Photographers over the years have gone to enormous lengths to keep their candid photography under wraps, ranging from fake lenses that took a picture at a 45 degree angle through a mirror system to cameras that were secreted inside innocuous-looking boxes. Perhaps the best method I've found, however, is simply to shoot from the hip. If you fit a wide angle lens, say a 28mm at least, and then set a small aperture of f/11 or more, then you've got what is virtually a focus-free set-up combined with a wide field of view. Cameras that offer a power wind and auto exposure will complete the dream combination: when you see a promising situation you can simply point the camera and shoot, without ever raising it to your eye to give the game away. You may not be able to follow the Cartier-Bresson rule of never cropping, because a little judicious work in the darkroom will tighten pictures produced by this method up no end, but it's still one of the best methods there is of working unobserved.

Pointer Practice makes perfect. Take a trip to a busy area, such as a market or a railway station in the rush hour, and try out your candid technique. You'll have plenty of failures but your success rate will soon shoot up. You'll also become adept at spotting situations developing, one of the key skills a good candid photographer has to develop.

'Candid photography is often full of lucky moments, and the more pictures you take the luckier you become.'

Candid

Mood

Nothing can capture mood the way that black and white can. This section shows how the subtleties of the medium can be used to convey the atmosphere that the photographer experienced.

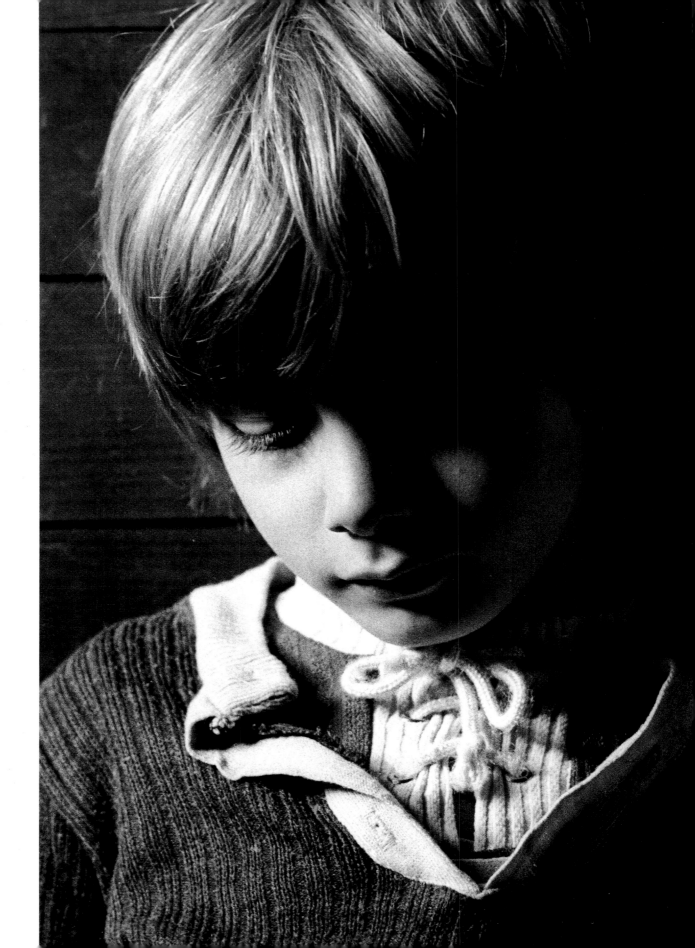

Mood

Richard by Terry Hope
Olympus OM1, 50mm, Kodak Tri—X film.
Exposure 1/60sec at f/5.6

This is my younger brother Richard, during his angelic childhood years. I wanted to set a picture up of him that was moody and atmospheric and as far away from a clichéd view of childhood as possible, but I also wanted it to be a simple lighting arrangement.

The answer lay in our garden shed: I decided to move the tools out and to use the space as a makeshift studio area, with the wooden wall of the shed serving as a textured backdrop. Lighting was natural and came flooding in through a window to Richard's right, and a little was bounced back onto the left of his face to relieve the shadows there using a large sheet of white polystyrene that was positioned against the wall. I set my camera up on a tripod, low enough to get me on the same level as my subject. Especially where children are concerned, there's usually nothing worse than a camera viewpoint that takes on the adult's point of view, and which looks down on the subject, and I wanted to make sure that I saw Richard as other children would.

As subjects for portraits, children are usually unbeatable. They've not yet learned to be shy of the camera and will give you a whole series of wonderful poses at the drop of a lens cap, especially if they're allowed to run around and be themselves. However, this was to be a slightly more formal sitting, and I wanted Richard to stay in one place for a period. I didn't want to impose an expression on him, however, and so I gave him a toy to play with and then sat back behind the camera and waited for what I considered would be the right moment. This arrived when he looked down at his toy at one stage, and there was no direct eye contact with the camera. His head tilted just enough to allow a scrap of light to reach his left cheek and I felt this was the picture I wanted. The shadows around him caused by the makeshift lighting arrangement only served to enhance the mood of the picture, and created exactly the atmosphere I was after.

Terry Hope

Pointer One further tip that I picked up through trying out this simple portrait arrangement was that it pays to be a little less than thorough with your window cleaning duties. When I took this photograph the window the light was coming through was filthy and covered with cobwebs, and consequently the light that reached Richard was softened considerably and with great effect. A later session that took place after the windows had been cleaned gave quite different results, with the light noticeably harder and more contrasty.

Mood

Mood

Liverpool Street Station 3am by Terry Hope
Olympus OM1, 50mm, Kodak Tri–X uprated to ISO 1600.
Exposure 1/30sec at f1.8

I was working on a project based around London's night workers, and I wanted to take some portraits that would capture the rather curious atmosphere that settles on the capital during the early hours of the morning. Liverpool Street Station during the day is a hive of activity, teeming with people streaming into and out of London. By night it's totally different. After the rush for the last trains just after midnight, there's a period of several hours where the station is almost slumbering itself, while a few parcel trains are loaded and dispatched and the station is cleaned and prepared for the mayhem of the following day.

The few staff who are on duty overnight look and act in a completely different way to their daytime colleagues, and I wanted to catch some unposed moments that would sum up the tiredness and the boredom that can settle at times. I felt the least intrusive method of shooting, and the one that would also enable me to capture most of the atmosphere of early morning, was to use the available light. I worked out that an ISO rating of 1600 would just about suffice to give me a shutter speed that would allow me to hand-hold, and I achieved this by uprating Tri–X two stops from its nominal speed of ISO 400.

There are several advantages to using black and white for a project such as this. Firstly it's very forgiving in terms of the latitude it offers, and I found I could use the camera's TTL metering in most situations to give me satisfactory results, which speeded things up no end.

You can obviously also forget any worries about colour temperature with black and white too, which meant that I could shoot under any lighting conditions with complete impunity. I also felt that black and white suited the subject of night workers admirably, and gave me the mood I was seeking to find far better than colour material could have.

Terry Hope

Composition I came across this railway worker relaxing in between jobs. He had seen me moving around the station taking photographs and had become used to my presence, and so I was able to approach him quite closely without disturbing him. I decided to position him just off centre of the frame, with enough of his surroundings revealed to give some indication of where he was. As I raised the camera and fired he carried on looking past me, oblivious to the fact that he'd just been captured on film.

Technique Uprating can be an extremely useful way of squeezing extra speed from a film. The Tri–X I wanted to use had a rating of ISO 400 which, in this example, would have given me a shutter speed of 1/8sec, hardly a practical speed for hand-holding. By setting an ISO rating of 1600 on the camera I was able to set a much more usable speed, and I then compensated for what effectively was a two-stop underexposure by giving the film an extra period in the developer. Most film manufacturers can supply a list of extra development times for their products to enable uprating to take place. As always, experimentation is the best way to determine the quality of the results that can be obtained by this method.

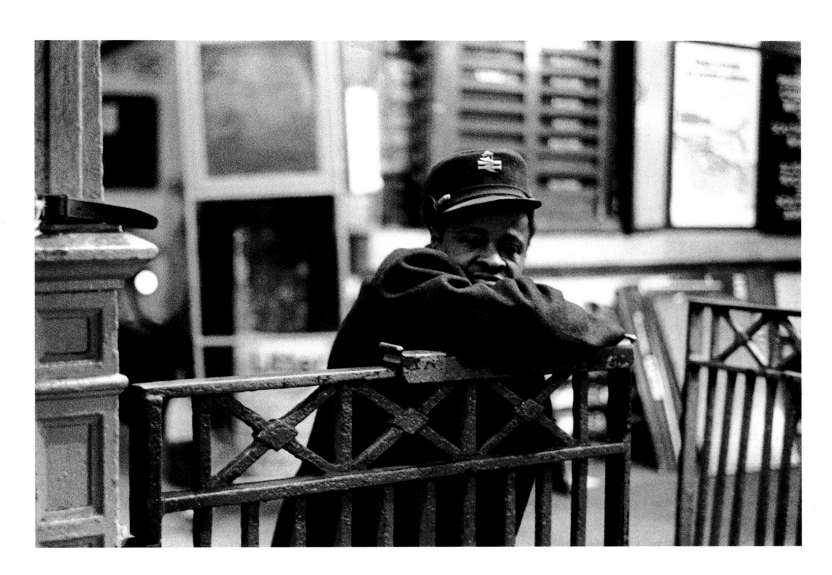

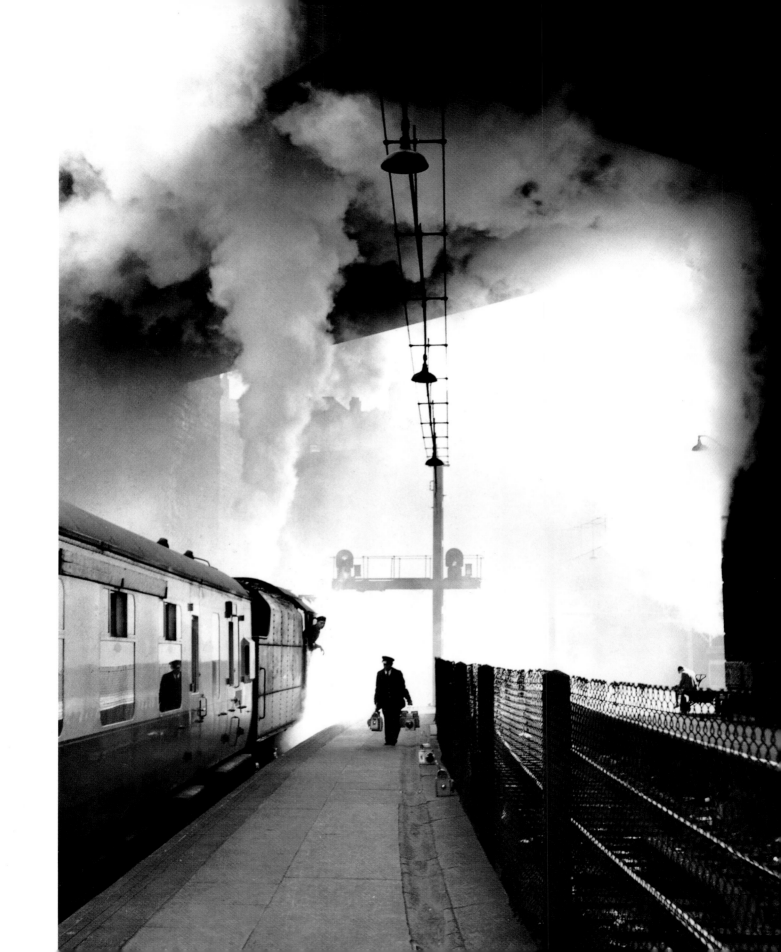

Mood

Liverpool Lime Street Station by Bert Hardy
Rolleiflex 6x6cm camera, fixed 75mm lens.
Film and exposure unknown

This is the classic portrait of a man at work, from the years when the steam train ruled the railways. This moody picture resulted from a shoot Bert Hardy undertook for **Picture Post** in 1954, and was an exercise in simplicity. As with so many of the stories he worked on for the magazine the theme was the ordinary person leading an ordinary life, and yet the pictures that emerged were time and again very special.

Here Hardy has focused on what was once an everyday scene at railway stations all around the world, but what could have been just a straightforward portrait of the railwayman with his hands full of lamps has been lifted by the skill with which the picture has been executed.

Primarily the space around the figure has proved vital, because it's allowed him to be isolated and picked out virtually as a silhouette. Interestingly there would normally have been some background behind him to spoil the effect, but Hardy had noticed that the steam from the engine had created an area of light tone against which his subject would be perfectly framed. The fact he's carrying lamps has also been useful, because it's meant that his arms are away from his body, and again this has given extra shape to his outline.

The final clever touch in this seemingly ordinary picture is down to the timing: by waiting for the right moment to shoot, Hardy has ensured that his subject is reflected in the carriage window. It's a small detail and the picture would probably have succeeded without it, but it's a sign of the thought that has gone into every aspect of the image.

Picture: Bert Hardy/Hulton Getty

Technique Strong backlighting can help you to create a dramatic portrait, and it was one of Bert Hardy's favourite visual tricks. Here the exposure has been calculated from the foreground, allowing detail to be retained here while the background, consisting of the far stronger daylight, has effectively been overexposed and has bleached out creating a high contrast picture. The steam and smoke emerging from the engine has added to the drama, and Hardy's skill has been in extracting the most from this situation. It goes to show that not all portraits have to be in the classic style: this is more a portrait of a profession than it is of an individual.

Composition The picture was originally shot on the square 6x6cm format, but cropping to create a vertical image has enhanced the composition. Many of the lines in the picture are verticals too: the plume of smoke from the engine, the signal post, the retaining wall to the right of the picture, and the crop has emphasised these elements. Hardy has also cleverly used the fence running down the right-hand side of the picture to lead the eye directly to his subject and to the centre of the picture. It's a classic compositional tool, and one that has worked very effectively here.

'By waiting for the right moment to shoot, Hardy has ensured that his subject is reflected in the carriage window.'

Mood

Stratos Vougas by Andreas Zacharatos
1949 vintage Rolleiflex TLR, standard Tessar f/3.5 lens,
Kodak T–Max ISO 400 film.
Exposure unknown

I love the work of the great jazz photographers from the 1950s, people like Herman Leonard, William Claxton and Francis Wolf. I've spent many evenings listening to jazz music from that period on my original vinyl records, and I found the excellent pictures that were used on the covers of these to be a great source of inspiration. When I was asked by the Greek jazz musician Stratos Vougas to shoot his portrait for an upcoming CD cover, I decided to take a picture that captured the mood of the photographers of this period.

I turned my model's apartment into a studio for this occasion, and used my usual lights which are actually designed to be used on a film set: Fresnel eights, 500W and 1000W. The advantage of using a tungsten source is that you can see precisely the lighting effect that you're getting, unlike flash which can be very hit and miss.

I put the main light slightly behind and to the left of my subject, so that it lit his profile and the back of the saxophone and also picked out his cigarette smoke. The second light was to the right of the camera and was reasonably high, so that it threw a shadow of him onto the wall behind. I put a neutral density gel across this source to cut the light down, so that it was giving illumination that was around one stop less intense than that from the other light, allowing an exposure ration of 3:1 to be created on the face of Stratos. A third light, covered with diffused gelatin to soften it, was used at ground level to pick out more detail on the saxophone and to throw a little extra light onto Stratos.

Andreas Zacharatos

Fresnel Key Light
500 Watt

Fresnel 500 Watt
with diffusion filter.
Positioned on the floor
(lower than camera)

Fresnel 500 Watt.
A little higher than
the camera's position
and covered with
a neutral density
gelatin filter

Technique The front of a Fresnel lens consists of concentric rings, each of which forms part of a curved lens face. These have the same overall convergent effect on illumination as a thicker lens. The Fresnel lens, however, is lighter, thinner and, like the cylinder head of a motorcycle, loses the heat applied to its inner surface through convection and radiation from its larger external surface area. The lights that Andreas used featured a light source that could be moved to bring it closer or further away from the lens. When the lamp moved close to the lens the light produced was flat and the shadows were very sharp, but when it moved further away the light was concentrated, much like a spotlight, and was very hard.

Pointer Cigarette smoke can be a useful element to use in a portrait. If you use a backlight and ensure the smoke is seen against a dark area, you'll be able to highlight it and make it a prominent feature.

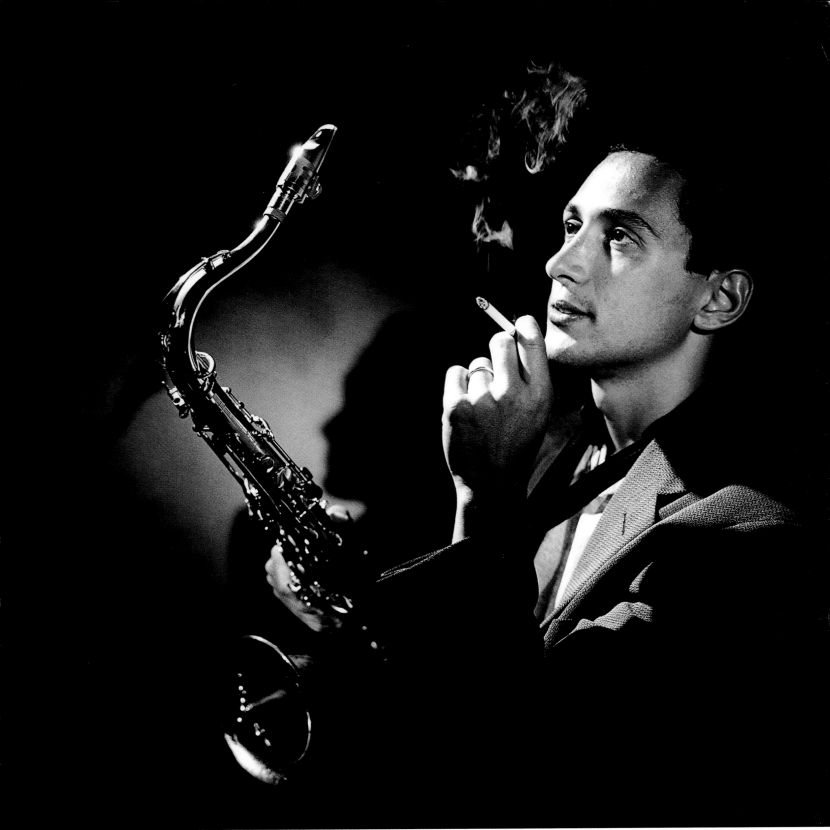

Photographing the model as she lay on her back, and then turning the print 180° created this effect

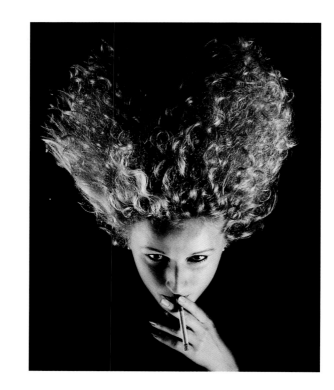

Mood

Like so many photographers I suspect, I love the mood and the style of the pictures that were taken by the great photographer Man Ray, and I was determined to create something that was very much in his mould, though hopefully with a little of Eric Howard in there too.

This was the image I came up with, very simple and classical and lit to give plenty of interesting shadow. You can often say much by using very basic lighting: for a more conventional portrait I would have lit from the front, but here I've used two small studio lights, one on either side of the model, to give a period feel. This set-up has left a small shadow down the middle of the face, something that I feel has added to the interest of the whole picture.

My model was a local girl from the small Dorset town where I live: her name is Philippa Webb, and she runs the local sheet music shop. She has the most wonderful flowing hair, and to emphasise this I asked her to lay on her back and to let her hair fall out behind her. The simple manoeuvre of printing the picture effectively upside-down gave it the appearance you see here, one that is initially deceiving and, I feel, very striking.

I shot to produce a strong, almost brutal portrait, calling on my experience as a commercial photographer with a pedigree of producing pictures for record sleeves. In this area you have to produce an image that will be immediately arresting, in order to catch the attention of the fickle record-buying public. That's what I was after: something strong and arresting that would have immediate impact while exhibiting a vintage appearance.

Eric Howard

Printing This low-key portrait isn't quite what it seems. I asked my model to wear a black velvet dress to soak up the light, and used a black background also, but still there was some tone around her that ruined the effect I was after. The only way I could achieve the density that established the mood I was after was to create a mask. I did this by producing a quick print that was half washed and then dried. Then I cut carefully around the hand and the face and more roughly around the hair, where the density of the background was deeper and there was less burning in to achieve. I attached this mask to a piece of thin wire and then placed it over the appropriate area of the print once I'd given the optimum exposure. By carrying on with the exposure, but moving the mask slightly to create a soft edge, I was able to give enough extra exposure to darken the background down to the required shade of black.

Pointer Inspiration can often come from studying the work of others. A good exercise for any photographer learning his or her trade is to look at a picture created by a master photographer and to attempt an interpretation. Sometimes a degree of personal input can lead to something completely new and original emerging. At other times the result can be a pleasing pastiche of another's approach. What will almost always happen, however, is that the photographer will develop a greater understanding of how a picture was originally created, knowledge that can be stored and used in one's own individual approach. It's not cheating: it's learning!

Mood

Mood

Dancing Feet by Adrian Ensor
Nikkormat 35mm SLR, 35mm lens, T—Max rated at ISO 3200.
Exposure 1/30sec at f/2.8

These are dancers in a tiny pub in an Irish village, moving around to music played by a musician friend of mine, Christy McNamara. The atmosphere was everything here, and had I tried to use a flash or to frame my picture in a more conventional way, all the mood would have been lost. Instead I opted just to work with the small amount of available light that there was in the bar, and the blur and the grain that resulted gave an impression of the way it was on that night. Photography is about a lot more than simply making a record of an event. It should be about capturing some of the feel of an occasion, and the rule book often goes out of the window when you're working in a situation such as the one I found myself in here.

Christy is a photographer as well, and I picked up this particular style through looking at the pictures he'd taken of fellow Irish musicians, photographs that incorporated movement and subject blur. I found them very exciting, and it made me realise that he was capturing something through his approach that others, who perhaps were more technically minded, would miss.

This picture was taken during an expedition I made to Ireland with Christy. I had been told a tale in a pub in England one night about an old man's suit that was still hanging in a wardrobe in a ruined house on an island off Donegal, 20 years after the man had died. I was intrigued by the tale, and made it the basis of a pictorial journey, as Christy and I took to the road to head for Donegal. On the way we called into various places, and this bar was one of the first stops we made: Christy had his accordion with him, and he was playing along with a guitarist. As soon as they started their first song, people took to the floor and they danced all night. I hand-held the camera and exposed for the highlights on the floor, waiting for moments when the shapes that were being created by the legs of the dancers looked right.

Adrian Ensor

Composition Convention decrees that pictures should be framed in a particular way, usually to show complete figures and to follow the various compositional rules. These rules, however, by their very nature are made to be broken. David Bailey, for example, has a favourite saying that 'the only rule is that there are no rules'. He certainly has a point: the feet here say all that's necessary to be said about the exuberance of this particular dance night, everything else is extraneous and has ruthlessly been cropped out. Concentrate on what you're trying to say with your pictures, and if you can strip away detail that's not required you can pare your image down to the bare bones and make it easier for the viewer to understand.

Printing To give the Irish series a greater sense of continuity, all the images within it were finished in the same subtle shade of thiocarbamide tone. As with sepia, the toning process consists of two stages. First a print needs to be bleached and then it requires toning to bring back the strength and intensity of the image. By varying the strength of the two solutions that are mixed to make the toner, the final colour of the print can be varied between dark brown and a much lighter yellow brown. Printing dark has emphasised the mood of this picture: Adrian's philosophy is that if you print dark enough, you'll eventually see where the light is coming from. See page 118.

'The atmosphere was everything here, and had I tried to use a flash or to frame
my picture in a more conventional way, all the mood would have been lost.'

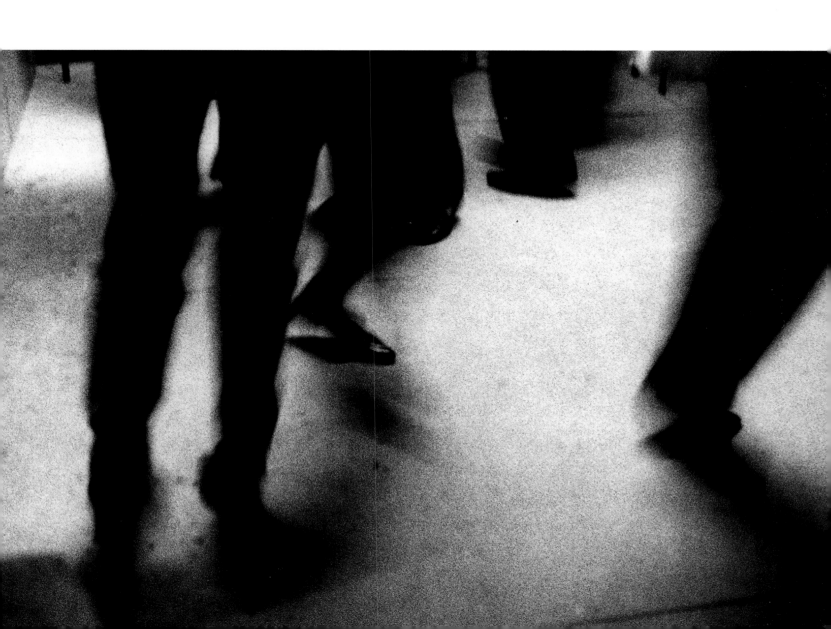

Mood

Portrait of a car mechanic by Chris Gatchum
Olympus OM2sp, 50mm f/1.8 lens, Ilford HP5 film pushed two stops to ISO 1600.
Exposure 1/60sec at f/4

I was asked to take a series of pictures for a project on a day in the life of someone in a particular profession. My landlord happened to be a car mechanic, and so I persuaded him to let me follow him around for a while and shoot some pictures that showed his routine.

I had a particular need for a portrait that could act as a cover picture, and although I was working mainly in a candid style I thought that this was a case where I would have to set something up. I was looking for good eye contact, but I wanted to produce something moody and atmospheric that would say something about the garage the man worked in and the kind of work he did. I asked him to wear the mask he put on when he was spraying cars, and then I used the available light that was coming in through the garage's double doors as a sole source of illumination. Because I had uprated my film two stops, I was able to set a shutter speed of 1/60sec, which was enough to allow me to hand-hold the camera. I moved in close with my standard lens, and filled the viewfinder with his face. The f/4 aperture I was using was wide enough to ensure that there was very little depth of field and this helped to accentuate his eye and to make the portrait more powerful.

Chris Gatchum

Pointer Because the light was coming exclusively from the side, it's grazed the subject's head and has highlighted the texture of his skin. Black-and-white film is particularly effective at capturing this effect, since it records in a series of tones and avoids the distractions that colour would offer.

Technique It's relatively straightforward to rate black-and-white films at higher ISO speeds to enable low light solutions to be covered. What you're doing in effect is giving the film less exposure than it requires, and so to compensate you need to increase development time. This will inevitably cause the grain size to increase, but usually this is within acceptable limits. Pushing two to three stops is quite possible without quality suffering greatly, and with an ISO 400 film this can mean that you're shooting at ISO 3200, perfectly sufficient for extreme low-light photography. Film manufacturers such as Ilford and Kodak should be able to advise you regarding increased development times for specific black-and-white films.

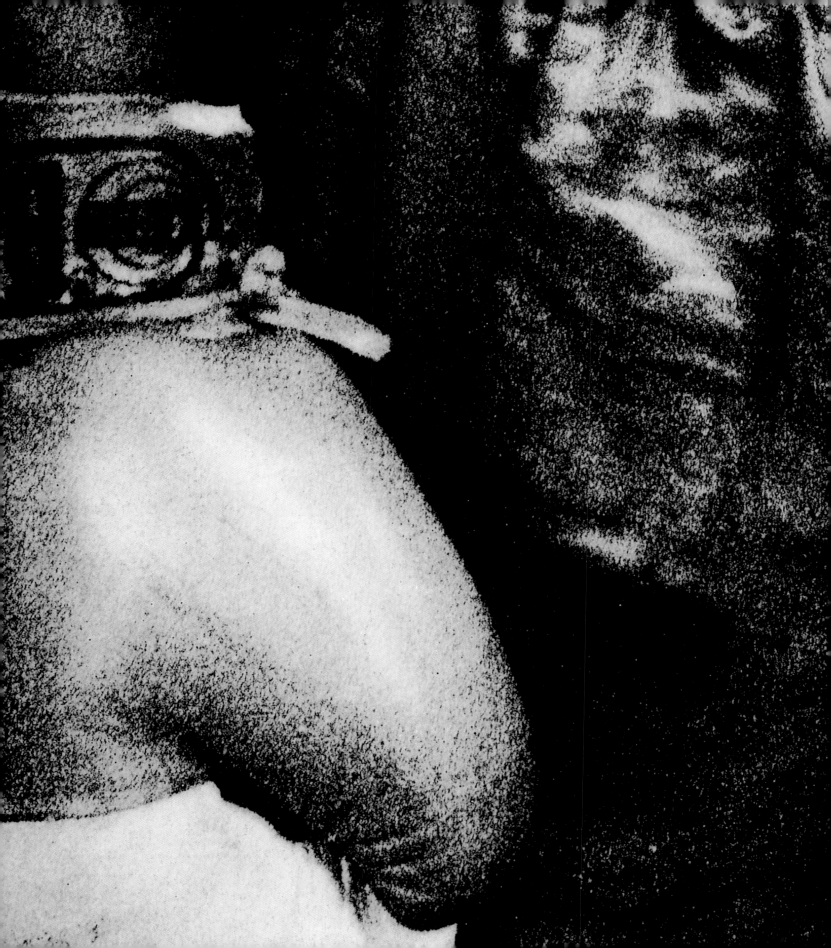

Gallery

It's time for a treat. Sit back and enjoy this collection of wonderful pictures from a selection of great portrait photographers.

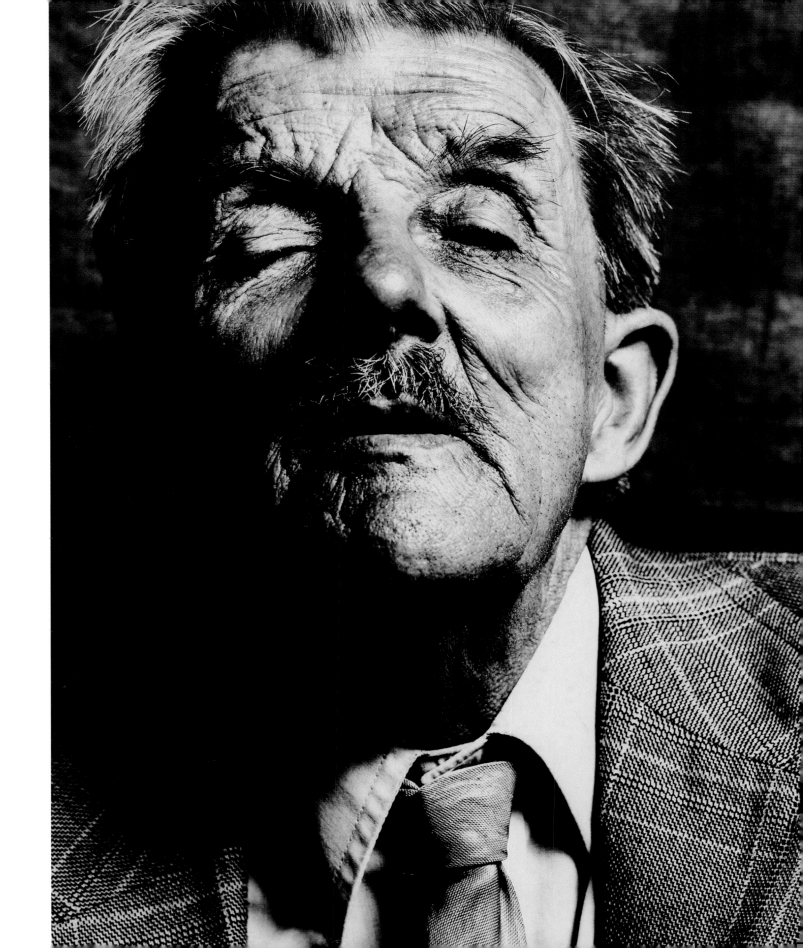

Jimmy Forsyth, Photographer 1987 by John Claridge
Mamiya RZ67, 140mm lens, Agfa APX 100 film.
Lit with one Balcar flash, lens set to f/8

Boxer in Old Havana by Adam Hinton
Leica M6, 35mm lens, Fujifilm Neopan 1600.
Exposure 1/30sec at f/2

Gallery

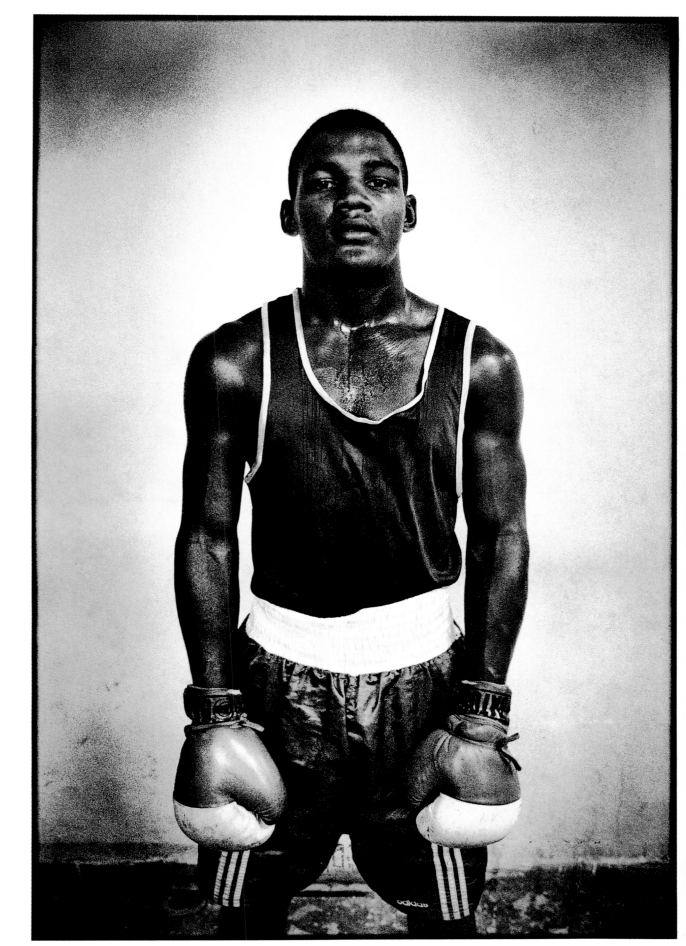

Theo Kogan from The Lunachicks, backstage at the Reading Festival 1993 by Derek Ridgers
Nikon FM2, 24mm lens, Ilford Delta 400 film.
Exposure 1/30sec at f/8

Shakespearean critic Harold Bloom by Eamonn McCabe
Hasselblad 6x6cm camera, 150mm lens, Tri-X uprated one stop to ISO 800.
Exposure 1/60sec at f/8

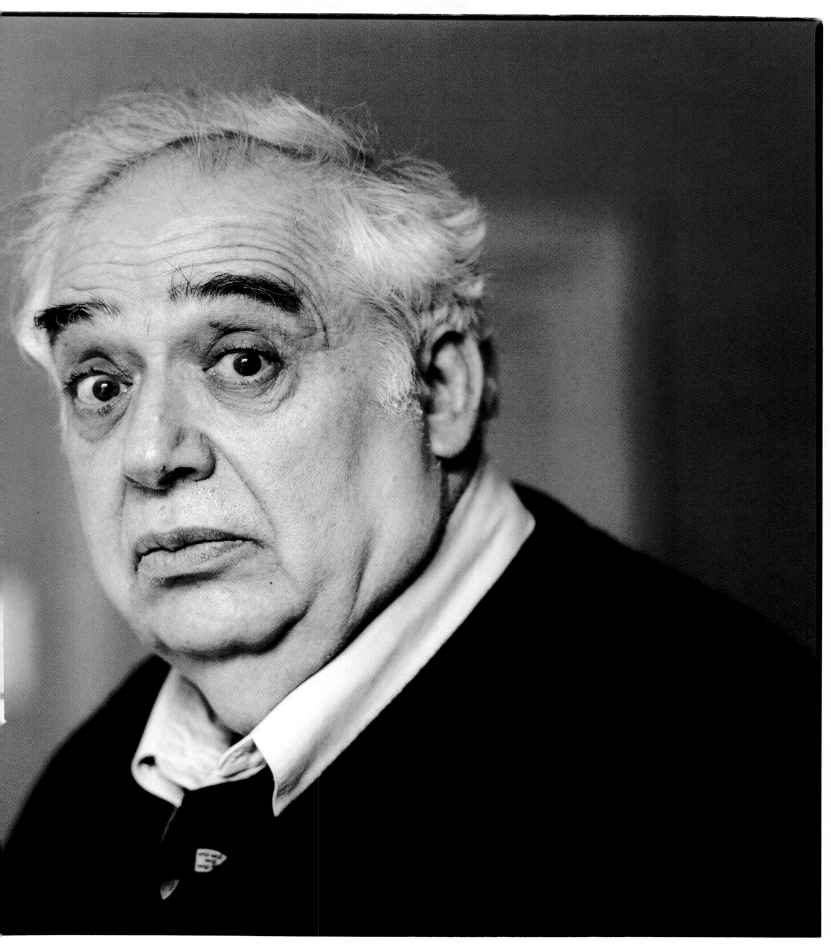

Gold Rush Town Old Timer by Ron Bambridge
Mamiya RZ 6x7, 110mm lens, Ilford HP5 film.
Exposure 1/60sec at f/11

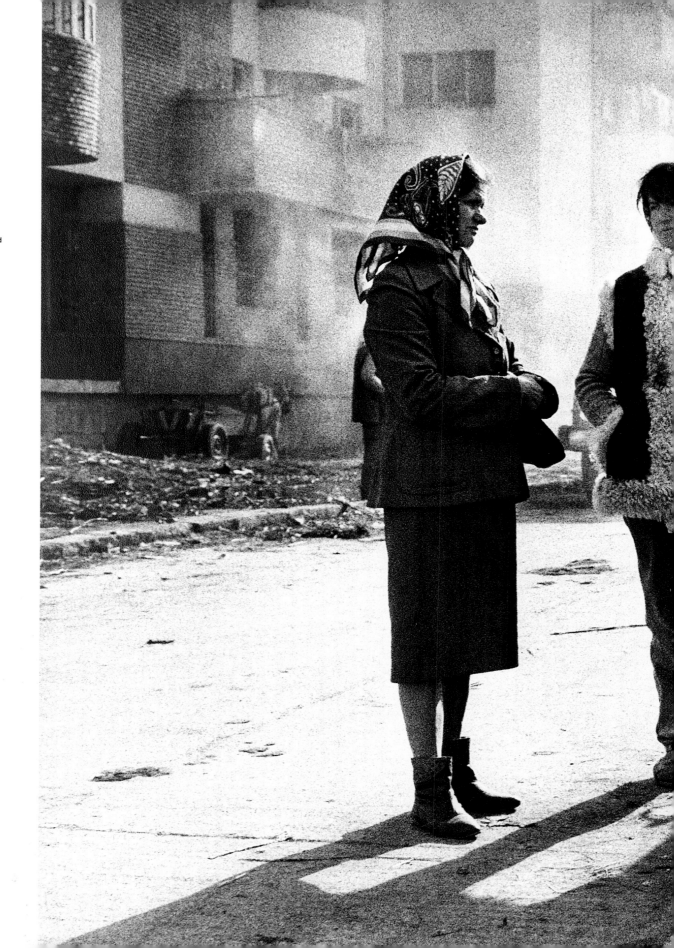

Romanian Free Market by Eric Howard
Contax 139, 28mm, Agfapan 400.
Exposure 1/125sec at f/8

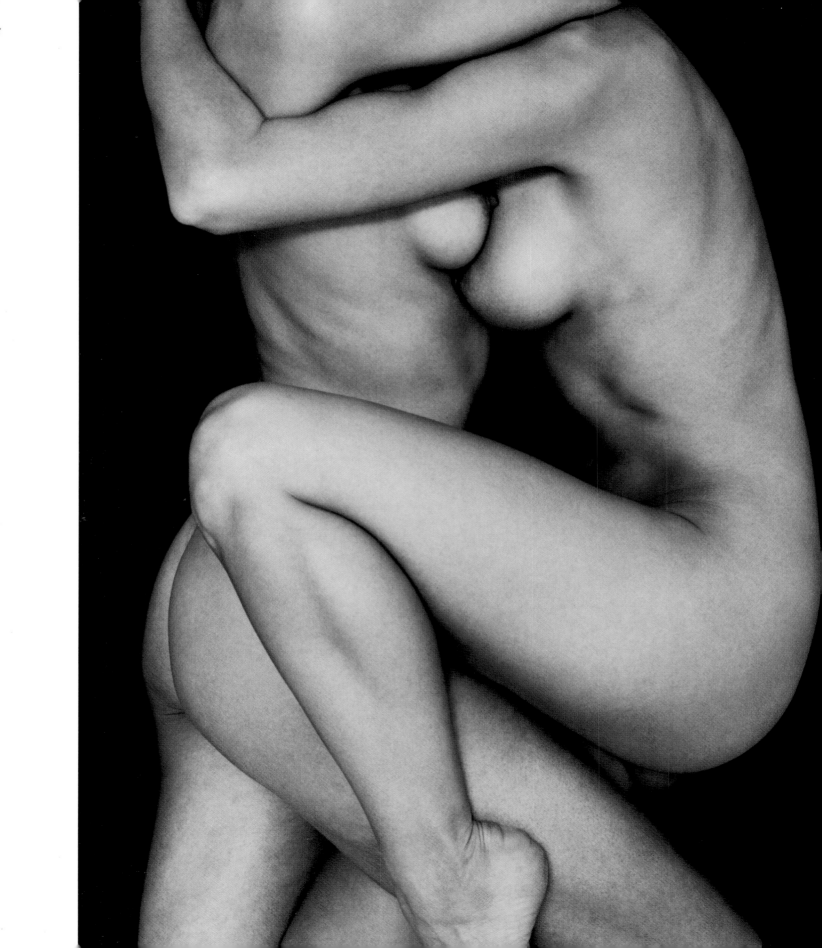

Couple Entwined by John Swannell
Pentax 6x7, 200mm lens, Kodak Plus X film, ISO 125.
Exposure 1/30sec at f/11

Technique

There are many ways to tackle portraiture. In this section photographers explain some of the techniques they've used to produce images that are strikingly different.

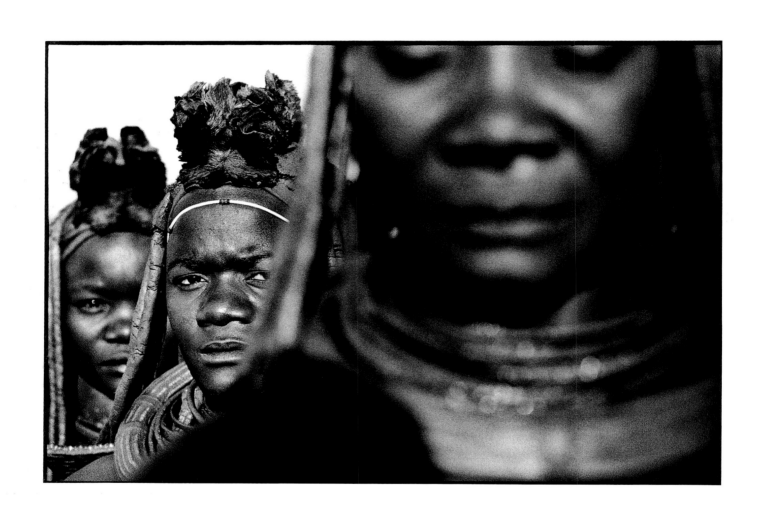

Technique

Himba People by Adam Hinton
Leica M6, 90mm lens, Fujifilm Neopan downrated one stop to ISO 200.
Exposure 1/1000sec at f/4

I very rarely use the 90mm lens with my Leica, but occasionally its qualities can be extremely useful to me. I took this picture of Himba people, who live in Namibia on the Angolan border, as part of a project I was working on to record threatened indigenous populations. By choosing my vantage point carefully, I was able to take this view looking down a line of them, using the peculiar compressed perspective the lens offered me to bring them apparently closer together. It gave them almost a statuesque appearance, which I really liked. With a longer lens I could have stepped back more, and it would have been easier to achieve this effect, but the 90mm was still able to give me an interesting viewpoint.

The reason I was here is that the Himba are facing the prospect of having their ancestral lands swamped by a new dam, and I wanted to show how their strong cultural identity is helping them to fight back. There's enough in this picture to suggest much about these people and their character and, in this case, it simply wasn't necessary to show more. All I needed were certain elements – such as the characteristic Himba jewellery and the quiet determination in the faces – to tell the story in full.

Adam Hinton

Technique I was aiming to achieve a narrow depth of field to allow my focus to be tight on the central figure and to concentrate the attention on him. The problem I faced was that the light in Africa was so strong that I couldn't set the maximum aperture of f/4 that I wanted, even when using a 1/1000sec shutter speed. To get around this, and to allow the contrast to be dropped – particularly important when shooting dark skinned people in bright conditions – and for shadow detail to be added, I decided to downrate the film by one stop. This is the precise opposite of the more conventional uprating technique: the film is shot at a slower ISO rating and, to compensate for what effectively is overexposure, the film is developed for a shorter time.

Pointer It's important to do your homework before you embark on any project, because this can have a major say on whether or not you come back with what you wanted. I planned my visit to photograph the Himba people to coincide with an important local event, the visit by a local elder of the area to his father's grave, which was due to be attended by most of the local population. It gave me the ideal opportunity to photograph the people engaging in something that was linked strongly to their culture, but it was only research that had told me that this was the best time to go.

Narrow depth of field is a characteristic of a long lens. At an equivalent f-stop, the wide lens will give acceptable sharpness over a far wider area

Technique

Carmen II 1986 by John Claridge
Ebony 5x4in studio camera, 110mm wide-angle lens, Agfa 100 film.
Exposure 1/125sec at f/4.5

This was one of a series of nudes that I completed in the mid-eighties, and it's deliberately been kept extremely simple. I used one light and explored all kinds of shapes and textures, and for this picture I used the technique of setting a minimal depth of field. Just a matter of an inch or so of the then entire picture is in focus: in fact there's far more blur than there is sharpness here, and yet I feel that the quality of the image is exactly how I wanted it. Sometimes it's what you don't focus on that's every bit as important as what you do focus on and this, combined with the high contrast I achieved through the harshness of the lighting and the printing, has broken the image down into its most basic elements.

This narrow depth of field was achieved simply by setting the maximum aperture on my 110mm lens. I didn't employ any camera movements, though I could see exactly what I was achieving through scrutiny of the ground-glass screen on the back of the camera before the dark slide was inserted, and through this I could alter my focus precisely to achieve the effect I wanted. The wide-angle lens I was using ensured that depth of field was retained to the point where the detail of the shape in the background was retained, something that I felt was essential if the picture was going to work effectively. Nudes have always been a great inspiration to photographers and artists in general. I regard the female human form as a living sculpture, and I've been heavily influenced by great photographs of the nude taken over the years by the likes of Bill Brandt. Looking at great pictures by some of the photographic masters of the past should be a form of education for any aspiring photographer working today. That's not to say you should ever try to plagiarise them. You should simply allow their work to open your eyes to different methods and styles of working.

John Claridge

Composition The tightness of this crop has revealed all kinds of shapes and curves. The art of great composition, however, is to ensure that nothing ever is random: here John Claridge has worked hard to echo shapes and to create a frame for the whole picture by the graceful sweep of his model's arm. It's not just the natural shapes that have been exploited in this image. The lighting has been applied skillfully to throw corresponding highlights on the breasts of the model, and to create great symmetry in the picture.

Pointer The use of just one light is a great exercise for any photographer to undertake. Moving it around and observing exactly how it affects the modelling of a subject, and how it can create or destroy texture and shape is an object lesson for anyone planning to master the craft. This one light, even when used as here without a reflector, can also be highly effective and dramatic, and is capable of producing a whole range of different moods and feels. It's photography at its most basic and much can be learned through experimenting with its effects.

'I've been heavily influenced by great photographs of the nude taken over the years by the likes of Bill Brandt.'

Technique

Stretched Nude by Ivan Boden
Nikon 801 S, 50mm, Agfa APX ISO 400 film.
Exposure 1/125sec at f/4

I wanted to produce some nude studies that were all about form and shape, and less about the personality of the subject. After quite a lengthy thought process I decided the best way that I could achieve the look that I was after was to turn conventional quality on its head: I set the picture up and then deliberately threw the image wildly out of focus. This technique softened all the lines and shapes and created quite an abstract look, while still leaving enough detail in the image for it to be clearly recognisable.

I lit to achieve an interesting shadow effect. One light was positioned high and to the right of the model, bounced back down onto her from a reflector and with a second reflector on the floor to her left to throw more light back onto her from below. A second light was positioned to the right of the camera position, about two-foot off the ground and 10 feet away from her to add a small amount of fill.

The light from above has thrown shadows across the model's body. Although her hair is actually quite short, the shadow camouflages this point and creates an area of darkness to conceal her face entirely. The shadow also adds relief to her left arm and down the left of her body, emphasising the flowing shapes that can be found there.

In total I spent three hours exploring ideas and talking through and setting up a variety of poses with my model, and this was the one that ultimately I felt had worked the best. It's simple and effective and has all the soft and sensual qualities that I was looking to achieve.

Ivan Boden

Printing I wanted to emphasise the long slim shape that my model had made, and so in the darkroom I cropped to make a thin print that framed her quite tightly. I wanted to go further, however, and so I tilted the head of the enlarger a little to stretch the image on the baseboard. Normally this is a technique used to correct converging verticals, and it had the effect here of emphasising the shape my model had made still further. By staying within reasonable limits I made the effect believable and simply accentuated the look that already existed. The final stage was to sepia tone the final print, to achieve a warmer result.

My favourite tip I made my own backdrop for this picture by taking a discarded roll of out-of-date six-foot-wide photographic printing paper that I'd rescued from the bin, and then painting this roughly with a cloud effect. Because it was going to register out of focus in any case, all that mattered was that there was some tone in the background behind my model, and so my artistic efforts didn't need to be too precise. The same idea could be applied to any roll of standard white background paper, and it took very little time to do and proved to be an extremely effective and very economical way of carrying out the shoot.

Technique

Technique

Tattoo by Tim Brightmore
Sinar Norma 5x4in, 210mm, Polaroid Type 55 film rated at ISO 100.
Exposure 1/8sec at f/8

I thought that the use of a very shallow depth of field would be the ideal way of concentrating attention on this man's striking tattoo, especially if I lit the picture discreetly to ensure that there were large areas of shadow around the figure. The best way of achieving what I wanted was to use a 5x4in studio camera. Cameras such as this are based on the earliest designs, and are essentially nothing more than a light-tight box with a lens on the front and the film at the back. In between is a set of flexible bellows that allow the front and back of the camera to be moved in relation to each other, and certain movements will achieve particular effects.

Used conventionally, the movements can be used to correct converging verticals, for example, or to introduce enormous depth of field into a picture. What I did was to turn this latter technique on its head and to use the front movement of the camera to cut the depth of field down to an absolute minimum, just a matter of a few millimetres.

I used just one small tungsten light coming from the left of the frame with a reflector to the right to bounce a touch more light onto the top of the model's leg to make sure that the whole of the tattoo was revealed. Then, because the depth of field was so narrow and the shutter speed was relatively slow, I placed a support behind the model so that he could rest on this and could remain perfectly still. Even the smallest movement would have ruined the effect.

Eventually I took six shots of this set-up and achieved two photographs that I was really pleased with, which I think is a pretty good ratio.

Tim Brightmore

My favourite tip One of the best ways I've found to give direction to my work is to have a theme to explore. I've got a few tattoos myself and I find them fascinating, and through this I met up with a tattooist who introduced me to several of his most interesting clients. This led onto a series of shoots in my studio, and has resulted in a stimulating and rewarding personal project.

I've standardised on a method of photographing my subjects using a studio camera and Polaroid's Type 55 film, and this has given the series a distinct look which holds it together whatever the lighting variations might be. I've also called on my experience as a still life photographer to establish a style in my personal work, shooting my human subjects in the same way as I might shoot a studio arrangement, and taking ages over each set-up.

Now the idea is established I've got self-imposed perimeters within which to work, and this will guide me as I add further pictures to the series over the coming years.

Technique

Torso by Tim Brightmore
Sinar Norma 5x4in, 210mm, Polaroid Type 55 film rated at ISO 100.
Exposure 1/125sec at f/11

This man's tattoo covered much of his back and legs and, because it was all part of one overall design, I needed to photograph it as a whole. With this picture and subsequently the whole of the tattoo series I'm working on, I decided to shoot on Polaroid's Type 55 film, and to incorporate the edge of the film itself into the print to give it a dramatic frame. It also served to give the series a strong and immediately identifiable look and, of course, a rigid format.

Type 55 is one of the oldest Polaroid film materials available, and it gives the photographer both a print and a negative. It's inserted into a Polaroid back that slips into the back of the Sinar camera in the normal way and, on exposure, it's pulled out to release the chemicals held inside. Then it's given the usual processing time of one minute whereupon it can be peeled apart and a black-and-white contact print examined. This print needs to be coated quite quickly with a chemical film to prevent it oxidising, while the negative has to be cleared with a salt solution, but it's a brilliant way to work because you can see exactly what you're doing as you go along. You do have to take particular care, however, to frame the picture exactly as you want it, because if you intend to feature the edge of the picture there's no possibility of cropping, but again this is quite a useful discipline to learn. I take the negatives along to my printer to get them rewashed and dried properly, and then they're capable of being blown up to huge sizes if required.

The manufacturer's idea I'm sure is that the marks around the edges of the negative left by the developing chemicals should be cropped out at the printing stage, but in my opinion they really add something to the picture. By asking for these to be left in I've been able to introduce an element that ordinary film couldn't provide.

Tim Brightmore

Printing Master printer Adrian Ensor produces Tim's prints for him, and uses a 5x4in De Vere enlarger to hold the Polaroid negatives. 'I take the 5x4in carrier out,' he says, 'and replace it with a sheet of glass to allow the picture to be printed beyond its borders. It's big enough – just – to allow me to keep the complete borders of Type 55 in the print, and there's quite a steady demand for prints of this kind made from these Polaroid negatives. With Tim's prints I finish by toning them in thiocarbamide . I print quite dark, and then bleach the print back until the blacks are about to start going, and then I tone. This gives the print the particularly rich thiocarbamide tone that I wanted.'

Composition With the personal work I've been doing, I've been experimenting with the idea that I can create a valid and interesting portrait while showing just a part of the person. This particular picture is based around that idea, and the fact that I set my picture up just to show the model's torso takes away some of the distractions that would have occurred had I shown his face. I set the camera up on a tripod to offer a low viewpoint so that I was shooting flat onto the body rather than looking down on it, and I cropped in-camera to obtain a fairly symmetrical shape to the composition.

Technique

I wanted to explore the theme of body piercing, but to do it in a subtle and interesting way. Confronted by this particular model, I decided to create a very moody low-key picture, using just enough light to pick out the outline of the face. At the same time I wanted to make sure that his earring caught the light it needed to highlight it against the shadows.

As well as creating a dramatic effect, this lighting style also allowed me to accentuate the shape of the subject's neck and to pick out interesting details, such as the stubble that was growing on his chin. The use of Polaroid Type 55 effectively gave me a proof print each time I fired the shutter and allowed me to see exactly what I was getting as I went along, something that I found incredibly helpful.

I set the portrait up against a black backdrop to ensure that any spare light that might fall there would be soaked up, and then lit my subject with two tungsten lights. The first of these was the modelling light from a large softbox, which threw a patch of light onto the subject's back and also picked out the ring in the man's ear. The second light was a 1kw focusing spot with a fresnel lens, which gave a harsher light that could be controlled very precisely. This was used to provide some backlighting and to pick out the details I wanted around the model's chin and face, without throwing any excess light onto the background or into the camera.

Tim Brightmore

Mood The moody lighting I decided to use here allowed me to down play the character of the model to the point where I didn't give too much away about his personality. I wanted him to remain relatively anonymous, and for the jewellery itself to become the main theme of the picture. To have introduced another element by featuring the full detail of the man's face was, I felt, in this context unnecessary and potentially distracting.

My favourite tip Low-key lighting is not intended to be a complex business. I'll often try to set something up using just the one light if I can and, by using tungsten, I can judge visually how the arrangement is going to work. I'm experienced enough now to be able to judge the exposure I'm likely to need without resorting to a light meter, but Type 55 will, of course, tell you on the spot if the exposure you're giving is the correct one.

Body Piercing by Tim Brightmore
Sinar Norma 5x4in, 210mm, Polaroid Type 55 film rated at ISO 100.
Exposure 1/8sec at f8

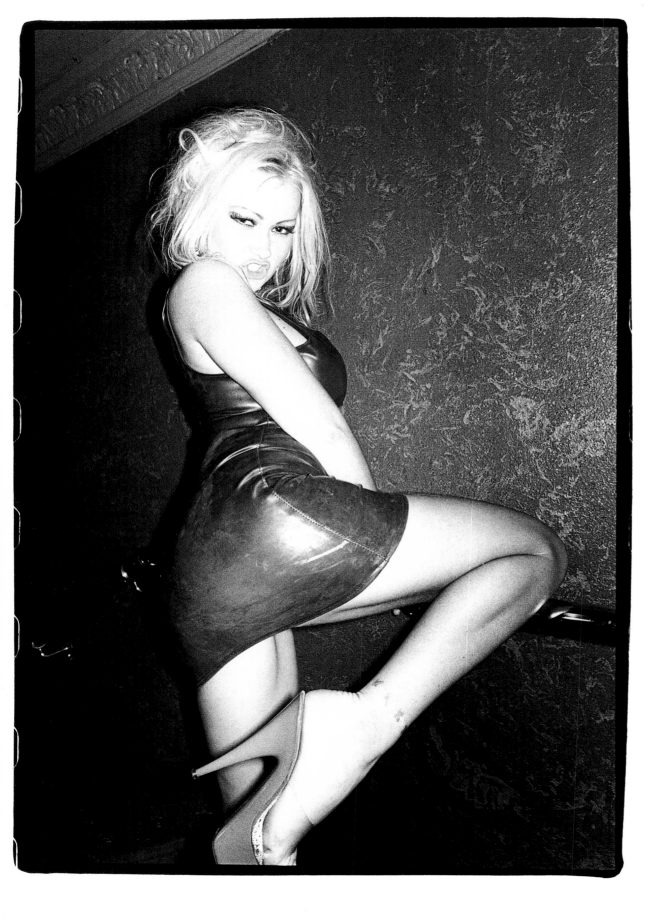

Technique

Skin Two Rubber Ball by Derek Ridgers
Nikon FM2, 24mm lens, Ilford Delta 400 film.
Exposure 1/8sec at f/5.6

The technique I used to take this picture of this woman at the
Skin Two Rubber Ball at Hammersmith Palais in 1995 is pretty
much the same as the one that I've used for all the pictures
I've taken of the club scene over the past twenty-five years.
I standardised on a camera, lens, film and flash arrangement a
long time ago, and I stick with this for all my club pictures. I know
exactly what I'm going to get and how I may need to adjust my
exposure to take account of any variations that I might encounter.
Apart from one change – a move to a 24mm from a 50mm in
1979, because the wider lens was better for the confined spaces
I was encountering – I've deliberately kept things constant to
give the project the continuity that I felt it needed.

The flash I use is a very basic Sunpak model, now discontinued,
which was the smallest non-automatic flash that I could find.
It's taped up and mounted upside-down on top of the camera,
with the wire from an old coat hanger bent around the camera's
lens barrel to hold it in place. The arrangement is primitive,
but it means that I can get the flash tube as close to the lens as
possible this way, which ensures that the shadows are kept to a
minimum. I could have used a ringflash, which is a flashtube that
circles the lens itself, to achieve a similar effect, but by the time I
discovered this I had already got my flash technique worked out
in a way that I was happy with.

I've been using this flash arrangement for so long that I know by
instinct what exposure will work. If I'm including a whole person
in the picture I'll be around five feet away, and I'll set the aperture
to f/5.6, if I'm shooting someone from the waist up I'll set the
aperture to f/8. If, however, I'm moving in on the face then I'll
work at f/11, which will give me the right exposure for a distance
of around one and a half to two feet. I don't work at the maximum
flash synch speed, however: I set a shutter speed of around
1/8sec or 1/4sec, and sometimes drop down to one second. It
won't affect the flash exposure, but it does mean that if my
subject has the background of the club behind them the ambient
light will allow some of the detail here to be registered.

Derek Ridgers

Posed I don't ask my subjects to adopt any poses, and nor do I tell them who I'm
working for unless they ask me. All I might do on occasion is to ask someone to move
so that they have something like a wall behind them, if the location that they're standing
in is too cluttered. The fact that I get poses such as this on occasions is entirely down
to the person in the picture. I don't discriminate on the spot: I photograph people who
look ordinary, as well as those who are exhibitionists, and I simply edit my pictures
down at a later time.

Pointer Setting a personal project, and adopting a clearly defined strategy to see
it through, can give a very useful structure to base pictures around. Derek Ridgers
started his project to photograph the club scene in the mid 1970s, but for the first ten
years it was carried out purely because his camera gained him access into places he
wanted to go. Once he realised that his body of work was growing, and was reflecting
the changing fashions that could be found on the club scene, Derek persevered and
has now built up an important archive of pictures that will one day be the basis for a
book and exhibition. The pictures were also picked up by **Loaded** magazine, one of
the UK's most successful and irreverent titles and, featuring in a regular monthly spot,
they've earned Derek a huge following.

Printing a

d Processing

The darkroom is the place where black and white really comes into its own, and where the creative process can be taken to new levels. Here the experts give a taste of what's possible.

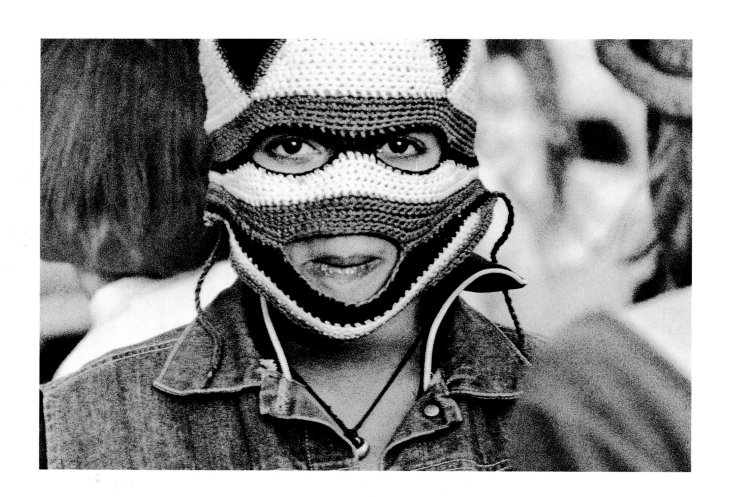

Printing and Processing

Masked Demonstrator by Dr Tim Rudman
Canon EOS 100, the mid-point of a 28–105mm zoom, FP4 Plus film.
Aperture f/4, shutter speed set automatically by aperture-priority mode

I took this picture during a demonstration in Trafalgar Square, London, and to maximise the impact of the eye contact and the sense of confrontation I decided to tighten the crop and to print onto lith paper processed in dilute lith developer. The use of lith material allowed me to control the detail and the density of both the lightest and the darkest areas of the print quite independently of each other. The strength of the blacks was determined by the amount of time that the print was in the developer – in this case twelve minutes – while the light tones were controlled by the amount of exposure that was given.

Before exposing my print I 'pre-flashed' the lith paper with uniform white light to improve the tonal range in the more difficult areas. Then I overexposed the paper by two stops. The space to the right of the figure was dodged for an extra third of a stop and then a further quarter of a stop through a diffuser to make the figure there less recognisable. The dark hair to the left was dodged for an extra quarter of a stop.

The print was developed in very diluted lith developer using one part A + one part B + twenty parts of water at 24 degrees C. Some old and well used lith developer was also added to the solution, something which I've found improves the colour and the lith effect. I also added some extra sodium sulphite to the solution to inhibit the pepper fogging (the appearance of random black dots across the print caused by sulphite levels becoming exhausted) to which this paper is prone in mature lith developer. Finally the print was fixed and washed to archival standards and left untoned.

Dr Tim Rudman

Composition By carrying out a tighter crop at the printing stage, I've been able to effect several improvements to the picture. It allowed me to place the subject in a much more central position than had originally been the case, and this allowed greater domination of the composition by the subject. The crop I chose also eliminated several unwanted peripheral details, particularly the white streaks and the hands on the left and the large plain bare back on the right. Reducing the relative size of the two figures to either side formed a much more intimate relationship between the subject and the viewer. Meanwhile the base and top crops have removed such things as fingers and other non-contributing details while emphasising the 'V' of the jacket around the chin. By cropping close on the top of the head I've placed more emphasis on the subject's eyes, making them compelling and rivetting to the viewer.

'To maximise the impact of the eye contact and the sense of confrontation I decided to tighten the crop and to print onto lith paper.'

Printing and Processing

Emilia sleeping by Terry Hope
Olympus OM4Ti, 50mm lens, Ilford XP2 film.
Exposure 1/125sec at f/5.6

This was a very simple picture, taken when Emilia was only a matter of a few weeks old. I noticed her sleeping soundly on a chair, and realised that the relaxed pose she had naturally taken up gave me the perfect opportunity for an impromptu portrait. I moved in for a close-up picture but, not wishing to disturb her in any way, could do little about the slightly messy background besides cropping most of it out in-camera. I quite liked the shadow area to her right, however, which I felt gave the picture a natural border on that side. The 35mm format left Emilia looking a little stranded in the middle of the frame, however, with too much space to either side of her. The shadow on the right-hand side of her face was also slightly too heavy. A reflector might have balanced things up a little but, as portraits of small children so often are, this was a picture taken on the spur of the moment, and there was little time to consider the technicalities.

Terry Hope

Printing and Processing Master printer Adrian Ensor took the negative away and worked his particular brand of magic to come up with an image that is far stronger. He started by tightening up the crop considerably, pulling in quite tightly around the child on the top and both sides. This concentrated attention on the subject, and removed the excess and unnecessary detail that was proving to be so distracting. Despite this step, however, the picture still retains almost exactly the 35mm dimensions that it started out with.

Next Adrian started to play around with dodging and burning techniques. 'I gave extra exposure down the right-hand side of the picture and along the bottom,' he says, 'and held back some of the shadow on the right-hand side of the face so that this area was lightened.' The picture was then printed several more times, Adrian making it progressively darker around the edges, while holding back the tone in the middle of the picture to accentuate the light falling there and to reveal the roundness of the face.

The final stage was to tone the print with thiocarbamide. Adrian worked first with test prints to achieve the colour of tone that he wanted. 'I tend to make prints slightly darker than they really need to be,' he says, 'because then I can bleach right back in the first bath, and this makes the thiocarbamide tone, which is applied in the second bath, much warmer.'

Technique Thiocarbamide toning is a two-bath process that consists of a bleach and a toner stage.

Formula Toner bleach; potassium ferricyanide 100g; potassium bromide 100g; add water to make one litre of stock solution.

Thiocarbamide toner – Solution A
Water (40 deg c) 750ml; thiocarbamide 100g; add water to make one litre.

Thiocarbamide toner – Solution B
Water 750ml; sodium hydroxide 100g; add water to sodium hydroxide – not the other way round – to make one litre.

Process Bleaching – For fully toned prints, dilute one part of bleach to at least nine parts of water, then immerse the print and agitate evenly until it turns a pale straw colour. For partially toned or split toned prints, increase the dilution and remove the print before all the silver has been bleached. Wash thoroughly to remove all yellow bleach stains.

Toning – Solutions A & B can be mixed in the following ratios to give varying shades of brown.

Sol A	Sol B	Water	Colour
10ml	50ml	460ml	Dark brown
20ml	40ml	460ml	Cold brown
30ml	30ml	460ml	Mid brown
40ml	20ml	460ml	Warm sepia brown
50ml	10ml	460ml	Yellow brown

Immerse bleached print into toner, agitate until print returns to its original density, remove and wash thoroughly. Take care not to breathe in the chemicals during the bleaching and toning processes. Work in a well ventilated room and wear a mask, and always handle prints with tongs or wear rubber gloves to prevent the skin coming into contact with the chemicals.

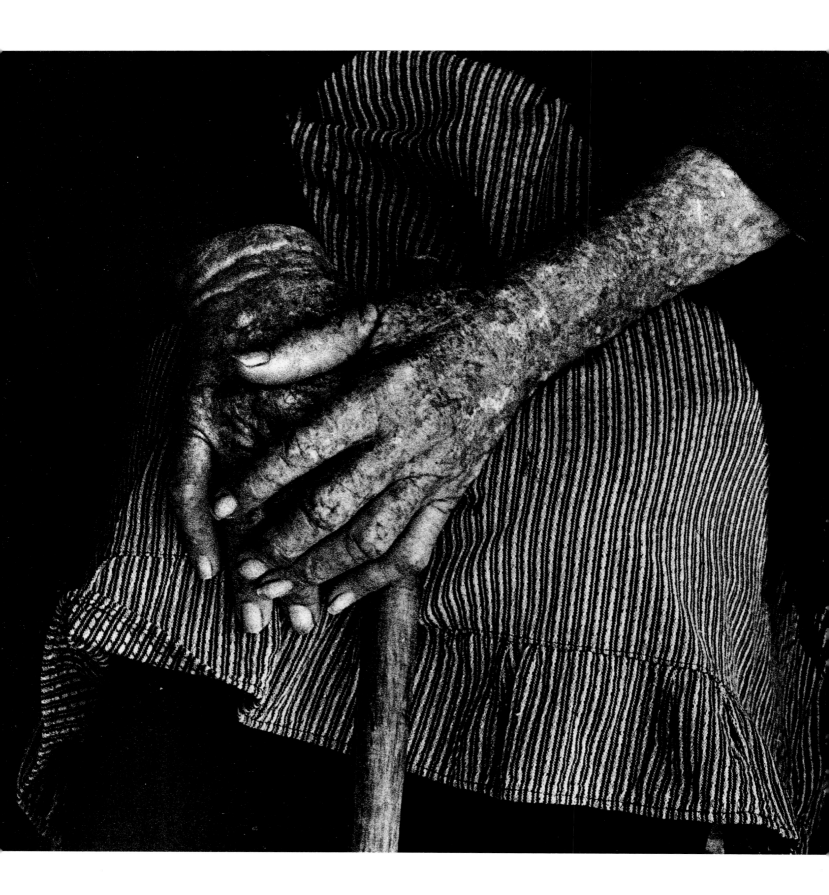

Printing and Processing

Portuguese Woman's hands by Dr Tim Rudman
Canon EOS 600, 50mm lens, HP5 film.
Exposure unknown

The extremely low light levels I was facing when I took this picture of an elderly Portuguese woman unfortunately meant that the picture I came away with was substantially underexposed and unprintable as it stood. To obtain a usable negative I used an intensifier: the best one I know for this problem is based on mercury which, unfortunately, is one of the most toxic of the heavy metals. Because of this, the sale of mercury salts is heavily restricted. If you use this formula you must take care to treat it with absolute respect, and you must wear rubber gloves when working since mercury can be absorbed through the skin. Disposal too has to be carried out under strict guidelines as mercury is toxic, non-biodegradable and environmentally hostile.

The formula is: Mercuric chloride powder 13gms; Magnesium sulphate purified powder 60gms; Potassium iodide USP granular 30gms; Sodium sulphite anhydrous (desiccated) 15gms. These should be mixed together in water to make one litre, which is used at 21 degrees C (70 degrees F). The advantages of this intensifier include the fact that it's easy to use and requires no bleaching, it can give up to five extra grades of contrast, it enhances shadow detail beautifully and its effect is reversible.

In this case I soaked the negative in water for ten minutes and then transferred it, emulsion side up, to a small dish containing the mercury intensifier. A yellow deposit gradually builds up on the emulsion and, after two to three minutes, a contrast increase of two to three grades is usually apparent.

I left it in long enough to allow the full increase of five grades, knowing that, had the result not been to my liking, I could have returned it to its original state by placing the negative in hypo and then washing it. The effect can be made permanent by immersing the negative in one per cent sodium sulphide for two to three minutes.

The straight print on grade 2 1/2 (see before) was still pretty flat. I then printed on grade 4 1/2 and used Farmer's Reducer (ferricyanide and hypo) to increase local contrast. I then fixed and washed the print, before completing the exercise by two-bath toning in selenium sulphide. This gives a further slight increase in contrast and tones the print a deep rich brown colour.

Dr Tim Rudman

Composition When I came across this elderly woman while on holiday in Portugal, her weather-beaten and work-worn hands immensely impressed me. To me they said everything about her, and the life of toil that she must have led. Although she didn't speak any English, her daughter and grand-daughter were there with her, and through them I managed to put forward a request for a photograph, and she agreed. She wouldn't, however, come outside the shelter where she was sitting and so, not wishing to use flash, I photographed her by the small amount of light that was available there. Her hands were loosely clasped together against the handle of her walking stick, and they rested against her patterned apron, and I decided that this was the picture. I moved in close enough to fill my viewfinder with this image, and the result I think says as much about the personality of this particular sitter as any conventional portrait could have done.

Printing and Processing

Sonia in Tin Bath by Allan Jenkins
MPP 5x4in camera, 150mm lens, Ilford FP4 film.
Exposure 4secs at f/5.6

I specialise in a Victorian process known as Cyanotype printing, which gives my pictures a vintage and quite timeless feel, and I've added my own touches to produce a finish that is uniquely mine.

I start with heavyweight 300gsm Arches Platine Water Colour Paper that has been 'seized', i.e. sealed, on one side so that it will take the coating of chemicals that I need to give it. Then I mix up my emulsion: I add 9gms of ammonium ferric citrate to 50ml of water to make one solution and 4gms of potassium ferro cyanide to another 50ml of water to make the other. These are then mixed together in equal quantities, at which point they become sensitive to UV light and need to be kept in a brown glass bottle to prevent deterioration.

I apply the liquid to the paper with a hake brush that contains no metal – metal would affect the ferric salts and allow it to dry. It's even possible to use a hair-dryer to speed this up, and once the drying process is complete I can make the print. Because this is done through contact, the print will be the same size as the negative, and so if I want something bigger than 5x4in I'll produce an internegative – a new negative produced to the size I want the print to be – to work from. The print needs to be exposed under UV light, which creates a chemical reaction. When the print is subsequently washed it oxides the ferric salts that have been exposed and removes those that haven't been affected, i.e. those that have been protected by the darker areas of the negative. When dry the print is a Moroccan navy blue in colour, and my touch then is to tone this with an assortment of acids, a process that stains and mutes down the highlights and lifts the shadows, creating a more uniform tone.

Allan Jenkins

Technique This picture was taken in the studio loft at my house, using just the natural light streaming in through a high window. I love the effect of this, and the way that it creates a gradation of tone across the body. Because the printing process I'm using works best with a punchy negative, I aim to get as much contrast into the scene as possible, and with the light levels I'm generally working with at my studio this means that exposures tend to be long. Four seconds was not unusual, but if the model is experienced there shouldn't be any problem with retaining sharpness in the picture.

My favourite tip White reflectors can be used to throw light back into areas where it's required, but it's also possible to use black reflectors to soak up light and to ensure that a certain area is guaranteed to be in shadow. This is what happened in the background here: to ensure the area behind the bath was in total darkness, a large sheet of black velvet was draped across, which has then recorded as pure dark tone.

'I apply the liquid to the paper with a hake brush that contains no metal since metal would affect the ferric salts.'

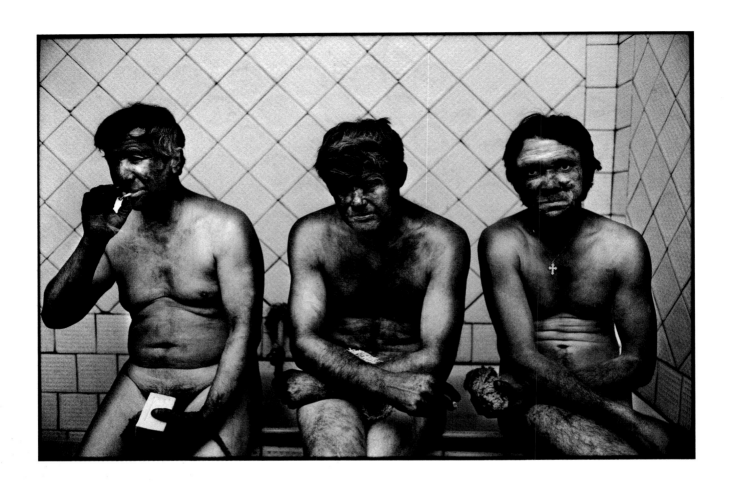

Printing and Processing

Miners in the old Soviet Union by Adam Hinton
Leica M6, 35mm lens, Fujifilm Neopan uprated two stops to ISO 1600.
Small flashgun bounced from the ceiling.
Exposure 1/50sec (flash synch speed) at f/2.8

I wanted to follow through a project that looked at the 'heroic' industries in the old Soviet Union after the collapse of communism. Miners had been well-paid heroes of the proletariat under the old system and, from thinking that the system would never change, they were now having to adjust to the fact that, almost overnight, it had all collapsed.

I managed to arrange to stay with the family of a miner who worked at the Sals Dombas Mine which was near Donetsk in the Ukraine, and I visited them eight times over a period of about three years. Eventually my project changed from being purely a documentary on the miners to being a story about the life of this one particular mining family.

The picture here was taken at the mine the day after I started the project. I noticed one of these miners having a quick cigarette before heading for the showers and I asked them if they would mind me taking a picture and they were happy to oblige. The light was so poor in there, however, that I wouldn't have got anything using available light even if I'd uprated to ISO 6400 (four stops greater than the film's recommended ISO setting). It meant that I had to use a small Sunpak flashgun, which I bounced off the ceiling behind me to achieve lighting that still looked natural.

Adam Hinton

Printing and Processing Because the light from the flashgun had reflected off the ceramic tiles behind the miners and created a hotspot, Adam's printer Gary Wilson was faced with a very difficult negative to print. 'Eventually I realised that the only way I could print it was to create a mask that would allow me to hold back exposure on the miners while giving the background something like one and a half stops more exposure,' he says. 'Trying to hold back the figures by hand would have left a series of halos and marks that would have ruined the picture.' Gary held a card under the enlarger about three-quarters of the way to the baseboard and drew around the outline of the miners.

'It was just a matter of cutting this out, seeing how it worked, and then trimming off extra pieces until the mask was covering the miners in the way I wanted,' he says. This wasn't the full solution, however. The three miners themselves required different exposures, the one on the left needing extra exposure to his body while the one in the middle was in shadow and required around thirty per cent less exposure than the miner on the right. 'The initial exposure was sixteen seconds,' says Gary, 'and while I was giving this I had to work very quickly to carry out, by hand, the necessary dodging on the miners. Once this exposure finished, I had to give another exposure for the tiles and, because this was a stop and a half brighter than the foreground, this worked out at sixteen plus eight seconds, i.e. another twenty-four seconds all told. While I was giving this I used the mask to prevent any more exposure reaching the figures. Once I'd finished this I gave the extra exposure to the miner on the left and burned in a few details, such as the cigarette packet he's holding, to finish the print.'

Technique Bounced flash will give a much more natural lighting effect than straight flash, because it will have been diffused through the action of reflecting from another surface. It will lose much of its intensity, however, and an allowance of around two extra stops will generally have to be given to compensate.

Nude by Randall Webb
Raj 10x8in camera, Agfa ISO 100 sheet film, rated at ISO 50.
Exposure 2secs at f/11

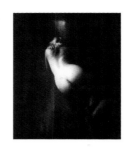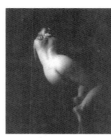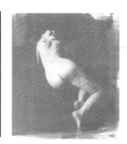

I took this picture as part of a workshop that I was holding
at Richmond College in west London. Because I wanted to
produce a large negative that could be used as the basis for
early printing techniques, I used a 10x8in studio camera (a copy
of a Deardorff), which I fitted with a 19th-century lens. I set up a
backdrop, and the scene was lit just with the window light that
was available. By downrating the film to ISO 50, half its nominal
rating, and then underdeveloping by around 10 to 15 per cent,
I took down the contrast in the scene and allowed more of the
shadow detail to record. I used the negative to give me the
pictures here: the red finish is a Gum Bichromate print, the blue
is a Cyanotype, the chocolate brown is a Van Dyck print while
the main picture, with the reddish brown finish, is a Salt print.

Randall Webb

Salt print Technique Mix up a two per cent solution of salt water by adding 20grams
of sodium chloride (sea salt from the supermarket) to one litre of cold tap water. Pour
this mixture into a clean developing dish and immerse the paper of your choice in it
and let it soak for around five minutes, and then hang the paper up to dry overnight.
Alternatively you could speed things up by letting the paper drain and then finishing
the drying process with a hair-dryer or a small fan heater. At this stage the paper is not
light sensitive, so the operation can be carried out in daylight.

Next you need to mix two separate solutions. One is a mixture of 50ml of distilled
water and 12gms of silver nitrate and the other is 50ml of distilled water and 6gms of
citric acid. When both are completely dissolved, mix them together and put the liquid
into a small brown screw-topped bottle ready for use. The citric acid acts as a
preservative and stops the silver coating from darkening before you can use it.

Now you need to coat the salted paper with the silver. This needs to be done in
subdued daylight or normal tungsten room lighting. Avoid working in a room with
fluorescent light. Then apply the silver/citric acid to the paper with either a flat brush or
a glass rod, and then dry the paper with a hair-dryer or a fan heater. The glass rod
method used for the print here, which involves squirting a line of the chemical under
the rod using a syringe and then squeezing this across the paper through several
sweeps, gives remarkably even coverage.

At this stage the coating is virtually invisible, so mark the back of the paper with an X
so that you know which side is the front. Now take your negative, which will work best
if it's contrasty, and place it dull (emulsion) side down on the coated side of the paper.
Place this sandwich in a printing frame and then place this, glass side up, in daylight or
sunlight or under an ultraviolet lamp. Within a few minutes the silver coating outside
the edges of the negative will darken. At regular intervals of three or four minutes
(more like once every minute if using the sun as the exposure source) unclip one part
of the hinged back of the printing frame and check the progress of the printing, taking
care not to move the negative and print out of register. When the print is exposed to
the point that all the tones are correct, and the highlights have sufficient detail, take
the frame out of the light and remove the print. If everything has gone to plan, you
should have an image that is a rich reddish brown and, if you've used the brush method
of application, you'll also have an irregular dark border caused by the silver being
brushed outside the confines of the negative.

The print now needs to be processed. In subdued daylight or tungsten room lighting
place the exposed print face up in a clean developing dish and wash it in running
water. The unused silver nitrate will turn the water slightly milky, and when this
disappears – usually after about four to five minutes – the washing is finished. Then
make up a fixing bath consisting of 500ml of cold tap water, 25gms of sodium
thiosulphate powder and 2gms of sodium carbonate, and immerse the print face down
in this for about five minutes. The colour of the print will change in the fixer to a
somewhat unattractive ginger brown colour, but it will revert to its original colour when
it is washed and dried. When fixing is complete, wash the print for thirty minutes in
running water, remove excess moisture with a sheet of blotting paper and then hang
the print up to dry naturally. The finished result should be stable enough to use and
display in the conventional manner.

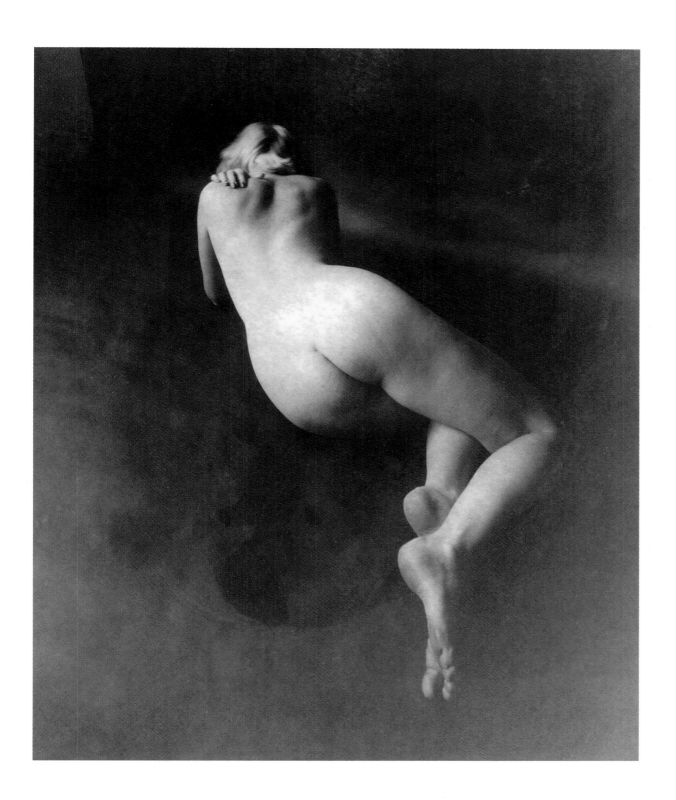

Finishing, I

Exhibiting and Websites

You've taken and printed your picture, and now it's time to show it to the world. Thanks to the Internet, the display possibilities that exist are wider than ever before and this section gives advice on how to make sure that you're doing your pictures justice when you present them.

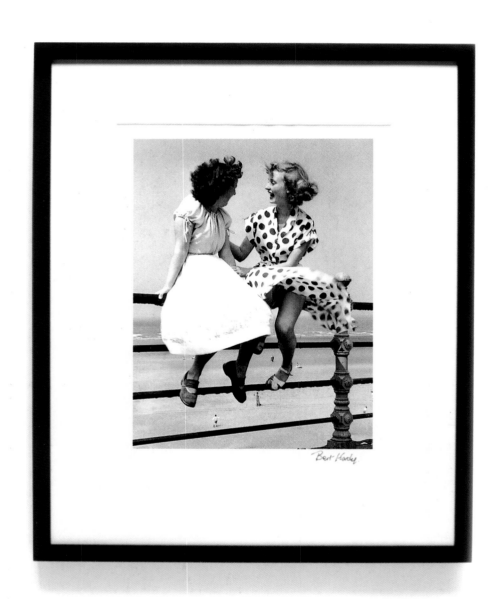

Bert Hardy

Finishing

Blackpool Girls by Bert Hardy
Kodak Box Brownie, fixed lens, 620 film.
Exposure 1/40sec at f/11

It's amazing how often photographers put maximum effort into the production and printing of a picture, only to neglect the final framing and mounting stage. And yet the presentation of a picture is a vital part of the whole process, and it's entirely possible that a picture could lose much of the impact that the photographer has worked so hard to achieve simply through lack of care in its finishing.

If you want your picture to last and to be shown off to best effect, there are certain key steps to follow. At the printing stage it's extremely important to ensure that fixing and then washing is extremely thorough. Toning can also add to the permanence of an image: a light selenium tone is used by many printers, because this has little effect on the normal black-and-white tones, but helps to make them more stable. Tones such as thiocarbamide and sepia will also add to a print's archival qualities, and the colour they add to a picture is often beneficial as well.

Once a print has been washed and dried, it should be carefully spotted with archival inks to make sure that there are no dust marks or hairs visible. The picture is now ready for mounting.

Mounting The job of the mount is to set the picture off, and to create an area around it that is plain and unlikely to distract. The width of this mount is down to personal choice, though some pictures that are printed as miniatures often benefit from a wider surround in ratio than prints that are larger. Keep the colour of the mount neutral – with black-and-white images white or light cream is the usual choice – because it will then be able to carry out its job efficiently and well, and the picture itself will remain the centre of attention. Great care needs to be taken over the cutting of the mount: generally specialist tools are required to ensure that a smooth bevelled edge is created. If you try to cut a mount using just a scalpel and a steel edge, the chances are that it will look messy and that you will slice through at least one or two fingers. Visit an art shop and ask for advice from the staff there, and they will recommend the equipment that you need.

The Print Room at the Photographers' Gallery in London handles thousands of valuable photographic prints every year, and often arranges the framing and mounting of pictures for purchasers. Print Manager Fiona Duncan explains the policy on mounts: 'Generally when we sell a print,' she says, 'we mount it in archival acid-free board. One board is used as the backing board, and on this we create three small pockets from archival tape which hold the print gently in place. The print doesn't need to be fastened any more securely than this, and this method allows it to be removed easily at a later date if required. Then a window mount needs to be cut so that it frames the picture, and this is connected to the backing board along one long edge using archival tape. This means that it's effectively hinged and can be brought across the picture, and then the picture is ready for framing.'

Framing Once again frames are a matter of personal choice, but often it's those that are the simplest in terms of design and colour that work the best. A black frame, for example, can look stunning when it's surrounding a classic black-and-white picture, whereas one that features a strong colour or an intricate design will start to fight the picture. 'The only other colour apart from black that might work on occasion, particularly with vintage black-and-white prints, is gilded silver leaf,' says John Dawson, a Director of John Jones Frames, who carry out much of the framing for the Photographers' Gallery Print Room.

'We would normally suggest that frames shouldn't be more than 1/2in wide for pictures up to around 20x16ins, while above that size the width can rise to 3/4in without becoming too dominant. The mount should ideally be around 3ins in width increasing to 31/2ins at the bottom for prints up to 20x16ins, and again this can rise a little, to 4ins perhaps, for larger prints.'

The final stage of the framing process is the selection of glass and, for archival purposes, you should select a material that offers UV protection, because this will give your print a longer life, particularly if it's going to be hung in a room that attracts a lot of daylight.

John Jones Framing Department can be contacted on 020-7281 5439

Exhibiting

Therese with Anvil by Allan Jenkins
MPP 5x4in camera, 150mm lens, Ilford FP4 film.
Exposure 2secs at f/8

Having my first major exhibition was an amazing experience. Up until that point I'd been working for around six to seven years to develop an individual style, and I'd been taking pictures largely for myself. Seeing my photographs mounted, framed and hanging on a wall was a great moment of realisation for me, the point where I suddenly understood why I had been doing everything. It was extraordinary to see people's reactions to my work: I had my own favourites, but people would invariably go for others that I would see mistakes in, and they either didn't see or didn't care about what I thought were failings.

You can get absorbed in your work, and then it's difficult to step back, so the input I got from other people on my choice of pictures to display was invaluable. It was particularly useful to hear the opinion of the owners of the gallery who were mounting the show, and who obviously had to come from a more commercial direction than me. I had around 200 pieces of work to select from, and they told me which pictures they thought might be too provocative, and helped me make a selection that we all were happy with. They also undertook the framing and mounting of the pictures, which were displayed in very classical frames with plain white mounts. The mounts gave an important area of clarity around the picture, something that was really needed because they are very low-key and quite dark.

Allan Jenkins

Technique The picture of Therese was taken using the natural light coming through a high window in my studio. The quality of this light changes throughout the year, and so the results I get using this location tend to be different every time, and I enjoy this unpredictable element. The prop I used here is an anvil that I borrowed from my neighbour who's a metal worker. I often use props that I think will be interesting, but I don't usually plan what I'm going to do with them, preferring to shoot by instinct. Here the contrast between this hard and heavy object and the gentle curves of the model's body has given the picture its impact.

Pointer Putting together an exhibition is one of the most satisfying ways of using your pictures, whether it's a show at a major gallery that you're putting on or a small display at your local library. Before you even start you have to make sure that you're really ready to go public: a theme for your work is essential, and, like Allan Jenkins, you must be sure of your own style, because work that's too derivative will be found out immediately. Making the right selection is the next problem: Eamonn McCabe has this advice. 'I was looking for themes within themes with my portraits,' he says, 'perhaps picking out thirty or so that were women, thirty that were men, another selection that were taken in hotel rooms, that kind of thing, and then I made rough prints of everything. I had five or six pictures that I knew I wanted to include, but with the others I had good friends I could bounce pictures off, and they would give me an honest opinion. You shouldn't rely totally on the advice of others, however, because otherwise your show will be chosen by committee. I think that, after living with the pictures for a while, you should get a gut feeling about what's working and what isn't, and you should have the confidence to go with that.'

Websites

www.photography.gr

Introduction Set up a personal website and you've established an exciting and cost effective way of showing your photographs to a potentially unlimited worldwide audience. Best of all, you'll be in charge of the content and the presentation, and so you have far more freedom to express yourself than you would normally expect from a conventional exhibition outlet.

What you will need The first essential piece of equipment you require is a computer. The very minimum would be a 486 with Windows 95, and this would be the 'very minimum'. Recommended though is a Pentium. Whatever computer you decide on should have at least 16 megabytes of RAM. Do remember though, your hard drive i.e. amount of space on your computer, will slowly be eaten up the more programs you load, which will in turn slow down each action you do. Therefore, 32 megabytes of RAM would be more realistic. You'll find this extra RAM really useful when scanning and editing.

Next you will need a good scanner, with a minimum resolution of 72 pixels per inch (ppi). Again, this is the very minimum. Higher resolution scanners are advised, because the quality of the scanned image will be even higher. However, there is a fine balance between image quality and its size, in terms of megabytes. The greater the file size, the slower it will take to appear on the Internet. However, regardless of the resolution you save your image at, it will be no greater than the resolution of the computer screen, typically 72 or 96 ppi.

Once pictures are scanned, you could alter them on an image editing program. Photoshop is widespread. The capabilities of such programs are vast but, at a simple level, you could create electronic frames and borders, lighten or darken your image, change its size or add a tone. Additionally, you could watermark your images, that is to say give it an electronic signature, and this will say that the image is yours. Although you cannot stop people copying your images from the Internet, at least if they appear again you can prove they are yours. Remember to save your image. The Internet supports gif or jpg, e.g. your image.jpg. Note, all names on the Internet are in lower case.

The time it takes an image to appear over the Internet is a function of its file size. For a benchmark, colour images should be approximately 80Kbytes in size, while black and white should be an 1/8th of the file size. This is based on an image measuring about 5cm x 3cm. It can also be useful to use very small images, known as thumbnails, which will download in a fraction of the time. Then, if people are more interested and want to see more detail, they can click on the thumbnail, and a larger version will download. They will be more prepared to wait for something they asked for. For this to be effective, put a meaningful title against the thumbnail.

Now you need to put some text to your pages. If you're bringing text and images together, and don't want to learn pure HTML, you can use programs such as Front Page or Page Maker, which are simple drop and drag web-editing programs. Each page you complete needs to be saved as a htm file, e.g. photos.htm, though the first one has to be called home.htm, which will subsequently serve as your home page.

www.trevillion.com

cityart.net This highly successful website – currently getting over 2000 visitors a day – was created by web developer Debra Palmer, and was considered so innovative and attractive to use that it was runner-up in two categories in a major competition for websites held by The Times newspaper. The site, which was created on less than 10 megabytes of space, contains forty-five examples of investment art in a series of galleries, complete with essential details such as price, condition of picture and so on. It also has links to several other sites of interest to photographers and investors, such as The Royal Photographic Gallery and Photographers in New York, a listing of dozens of top photographers, several of whom have themselves links to other sites.

How do I transfer my files to the Internet? First you need to register with an Internet Service Provider (ISP). These are widespread now, and normally free. As well as providing you with an email address, they typically supply an amount of web space, e.g. 10 megabytes. You will want to give your website a name, so people can find you. If you register your website name with your ISP, invariably, their name will be the prefix to your site, i.e. www.isp name/your name.com. You could, however, register a unique name, without the mention of your ISP, which should only cost around £50 for two years, i.e. www.your site.com. This was the case with www.cityart.net, which was registered to give our website a professional-sounding name. Without getting technical, you have to ensure with your ISP that your registered name is 'pointing' to your site, i.e. web aliasing.

Having got your site name registered, you need to transfer your files to your web space. This sounds complicated, but actually isn't. You will probably use 'ftp', which stands for file transfer protocol. Basically, all you have to do is to dial up your ISP and, via ftp, transfer your files to your web space. This is protected by a password, which you set.

How will I advertise my site? How will I get visitors? Difficult one! Just type in 'photography' into any search engine and see how many sites exist. So how do you get ahead of the competition? Placing adverts in journals can cost an arm and a leg. However, there are electronic ways. For example, find a popular site, contact them and ask whether they will include a link to your site; cityart is one such site that is developing such links. You can also incorporate the META Tags, which are key words that define your web page, in terms of HTML.

Finally, remember to include your email address on your website, so that if anyone sees your pictures and wants to contact you about them, all they have to do is to click on your address.

Debra Palmer

Websites

Biographies

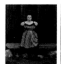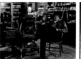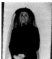

Ron Bambridge started his career in photography in 1975, when he began to assist **Vogue** fashion photographer Nigel Hartnup. He then moved on to work for a time at London advertising agency Foote, Cone & Belding. When he left, he decided to set up his own studio in the West End of London and to go freelance. Initially specialising in still life, his personal work turned more towards landscape and location portraiture. Armed with a new portfolio, commissioned work gradually progressed towards more location shoots for clients such as British Airways, Rothschilds, ICI, London Transport, British Gas, The Welsh Development Agency, Peugot and American Airlines. Ron has many awards to his name, including a Highly Commended in the Advertising & People category of the Ilford Awards in 1984, a best photography award in the 1988 National Business Calendar Awards, the Gold Award for the series 'Landscape' in the Association of Photographers Awards 1986, the Merit Award for the series 'People' in the AOP Awards 1988 and the Merit Award for landscape in the AOP Awards 1993. He also was a winner in the still lifes series category, the environmental series category and the environmental colour category in the 1997 London Photographic Awards. He won Silver and Merit Awards in the interior/exteriors category in the 1998 AOP Awards, and was included in the 1999 AOP Awards for his personal series of portraits. He can be contacted on 020-7486 7588, while his work can be viewed online at: www.contact-uk.com.

Ivan Boden has been fascinated with photography from the age of eleven, and he's spent the past twenty years pursuing this interest. He completed a BA in Photography at Dewsbury College and, after starting off primarily involved in social photography he's moved into areas as diverse as advertising, commercial, industrial and fine art photography. He recently travelled around Europe taking pictures, and has just completed an extensive fashion shoot in Cuba. He can be contacted on 0114-268 6434, and his email address is: ibstudios@yahoo.com.

Tim Brightmore has been working in photography since 1986, and originally trained in still life advertising. More recently, however, his work has been dedicated to the photographing of people, again within the realms of advertising. His non-commissioned work involves still life and portraiture, and the images included in this book are from a series he is currently developing which concentrates on people adorned with tattoos. Anyone with enquiries regarding Tim's work, or requests to see his portfolio, call 020-7278 4747, or email timber-b@msn.com.

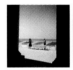 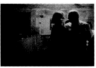

John Claridge was born in 1944 in London's East End and, from the age of fifteen to seventeen, he worked in the photographic department of a London advertising agency. He decided early on that photography was his vocation, holding his first one-man show at the age of seventeen, and then working as assistant to American photographer David Montgomery for the next two years. He opened his first studio aged nineteen in London's City area, and since that time he's worked for most leading advertising agencies and clients in Europe, the USA and Japan. His work has been exhibited worldwide, and he's been presented with over 500 awards for photography, both editorial and commercial. Selected pictures have been auctioned at Christie's in London, and his work is also held in the permanent collections of the Victoria & Albert Museum in London and The Arts Council of Great Britain Archives. He's published three books: **South American Portfolio** (1982), **One Hundred Photographs** (1987) and **Seven Days in Havana** (2000).

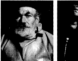 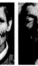 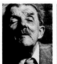 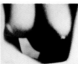

Adrian Ensor is one of Britain's finest black-and-white printers. He's a previous winner of the Ilford Printer of the Year Award, one of the UK's highest accolades for printers, and his London darkroom attracts orders from many of Britain's top photographers. Over the past eight years Adrian has been building a reputation as a gifted photographer as well, setting himself projects that he finds personally stimulating, and then pursuing them tenaciously. His work has now been accepted by the prestigious Photographers' Gallery print room, where it's offered for sale alongside pictures from some of the world's leading photographers.

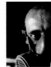

Chris Gatcum, having completed a photography GCSE and an art foundation course, spent a couple of years 'seeking a direction' to his life until deciding to return to college and to study photography full time on an HND at Carmarthenshire College in Wales. The course gave him the freedom to explore all genres of photography, from studio to location, people to still life and digital to traditional. Upon successful completion of the course, he was gently coerced into staying on for a degree top-up year, during which time he was awarded second place in the 1999 Jessops Student Awards. Since then he has become involved in set-building for high profile advertising jobs, while he's also taken the opportunity to build up a portfolio of work with which to begin his own adventure into the world of professional photography. Chris can be contacted on either 01730-894061 or 07979-002739.

Biographies

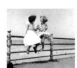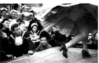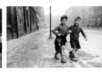

37 60 63 72

Bert Hardy was one of the UK's most distinguished photojournalists, and for many years was the chief photographer for the legendary **Picture Post** magazine. Born in 1913 near Blackfriars, he never lost touch with his working class south London roots. Very much self taught, he was an early user of the Leica 35mm rangefinder camera. He and other forward-thinking photographers of that time made full use of the flexibility and miniature size of the new format to produce pictures that captured action in a way that had never been seen before. His pictures of the poor areas in various cities are among the most powerful of their kind, and he was one of the first photographers to enter Belsen after its liberation, the most shocking experience of his life. Bert grew to fame during the Korean War, when his daring pictures of the Inchon landings won him many awards. Later he shocked Britain and America with his pictures of the ill-treatment of prisoners of war. After the close of **Picture Post** in 1957, Bert carved out a second career, as an advertising photographer, and he brought the versatility of the 35mm format to this area as well. He produced one of the most memorable advertising pictures of the era, the shot of a man at night standing on Albert Bridge in London that ran with the slogan 'You're Never Alone With a Strand'.

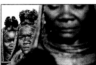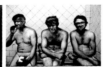

38 87 100 124

Adam Hinton has a multitude of photographic awards and distinctions to his name. He achieved a BA (Hons) Degree in photography at Trent Polytechnic in 1988, and since that time has worked for a number of major clients in the advertising and corporate sectors, such as the Midland Bank, Boots, Ericsson, Canon, the BBC, Texaco, the AA, Coca-Cola and Eurostar. He's also undertaken a number of major commissions for newspapers such as **The Daily Telegraph**, the **Sunday Telegraph**, **The Observer** and **The Times**, and magazines such as **Newsweek**, **The Telegraph Magazine**, **Stern**, **Der Spiegel** and **The Independent Magazine**. His awards have included being named a finalist in the 1998 Ilford Awards and the 1995 and 1996 Fuji Art Awards and being selected for the Association of Photographers Personal Series in 1995 and 1997. He gained a Merit in the Association of Photographers Personal Series Section in 1994 and a Silver in the same competition's Commission Series the same year, and was named Young Photojournalist of the Year in 1991. He has also exhibited widely, at celebrated London venues such as the Association Gallery, Hamilton's Gallery, the Photographers' Gallery and the National Portrait Gallery.

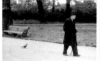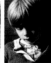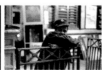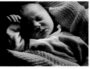

64 68 71 119

Terry Hope was born in 1956 and studied photography at Harrow College in west London in the mid-1970s. He moved into photographic journalism in 1981, running the features department of **Camera Weekly** magazine until 1989. After freelancing for a time he became Features Editor and then Deputy Editor of **Amateur Photographer** magazine, one of the world's oldest photographic titles, leaving to freelance again in the summer of 1998. He's now a regular contributor on a variety of subjects to the UK's national press, appearing in such titles as **The Times**, the **Sunday Telegraph** and **The Guardian**, and he continues to contribute interview features to the UK's photographic press. He has extensive connections with some of the world's leading photographers, and collaborated for four years on a regular column that David Bailey contributed to **Amateur Photographer**. He was named IPC Magazines' Commissioning Editor of the Year in 1995 for this and other projects. He can be contacted via email on: terryhope@brastedplace.freeserve.cc.uk.

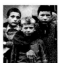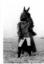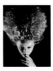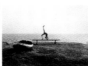

Eric Howard was born in 1951, and became an assistant to photographers Michael Legge and Peter Barry on leaving school at sixteen. In 1969 he decided to turn freelance, and in the period up to 1983 he worked for many of the biggest newspapers and magazines in the UK and abroad, and also sold original prints through Sotherby's and The Photographers' Gallery. From 1983 to 1986 he worked as Creative Director at Photobanc, overseeing calendars for such names as John Swannell and Bob Carlos Clarke and even producing one featuring his own work. In 1987 he returned to selling original fine art prints, including among his clients Lord Palumbo, Sally Cadbury, the **Financial Times** and the Royal Photographic Society. In 1991 he was approached by Mary Gibson, the founder of a fund for Romanian orphans, to take pictures in Romania to raise awareness of the crisis there, and his work eventually raised £20,000 for the charity. Two years later Eric was the Project Director involved in setting up and launching **Photo Art** magazine. The RPS awarded Eric the Gold Medal in their annual exhibition in 1995, and the same year he acted as a consultant to the Duke of Edinburgh Award's Charity Photographic Auction which took place at Coutts Bank in London. Eric set up cityart.net, a virtual gallery for selling art and photographic art on the Internet in 1997. His own work, and that of a selection of other major photographers, is available for sale either through the site or by contacting Eric on his email address: eric@cityart.net.

Allan Jenkins is a purist and a traditionalist, working only with natural light and using old-fashioned alternative non-silver processes. These methods were first practiced in the 1890s, combining ferric salts and carefully exposed UV light, which cooks the images slowly into the fibres of the paper through the density of the negative. Allan's work is dark and mysterious; every print a curious mixture of new and old. He describes his pictures as 'a fusion between painting and photography, joining forces as an art form influenced by traditional and classical art.' Allan is represented by the Hackel Bury Fine Art Gallery, 4 Launceston Place, London, W8, tel: 020-7937 8688.

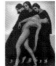

Rudolf Koppitz was one of the leading representatives of art photography in Vienna during the years between the world wars. Beginning in 1924 and continuing until his death in 1936, Koppitz exhibited in pictorialist salons throughout continental Europe and in England, Scotland, Wales, New Zealand, Canada, the United States and Japan. A brilliant worker in the process known as bromoil transfer, it is as an image-maker that his importance rests. His photographs from the 1920s and 1930s were fascinating in perspective and the use of symbols. At a time when much of pictorial photography was banal, Koppitz's images were psychologically provocative. He created illusions; he related equally to mythology and reality, and through this sought to stimulate the complacent viewer into a new way of seeing.

Biographies

Eamonn McCabe is one of the most respected photographers and commentators of his generation. He studied film at San Francisco State College in 1969, and became a photographer with **The Guardian** in 1975, leaving to work for **The Observer** in 1977. He stayed there until 1986, picking up an unprecedented string of awards as a sports photographer in that time. He was named Sports Photographer of the Year no less than four times, in 1978, 1979, 1981 and 1984, and was News Photographer of the Year in 1985. He was named Official Photographer for the Pope's visit to Britain in 1982, and then became Picture Editor of **Sportsweek** magazine in 1986. Since 1988 he's been the Picture Editor of **The Guardian**, and was voted Picture Editor of the Year by his peers in 1992, 1993, 1995, 1997 and 1998. He was the Fellow in Photography at the National Museum of Photography, Film and Television in 1988, and was made a Fellow of The Royal Photographic Society in 1990, and an Honorary Professor at Thames Valley University in 1995. He's exhibited at the Photographers' Gallery and the Barbican Gallery in London, and at the National Museum of Photography in Bradford, and has three books of pictures to his name. He can be contacted via email on: eamonn.mccabe@freeuk.com.

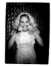

Derek Ridgers, despite telling women in bars for years that he is only 29, was actually born near the brewery in Chiswick, west London around 1950. A difficult youth, it was thought that he might be artistic and he was sent to Ealing School of Art where he even managed to lose out in matters of the heart to a then heterosexual Freddy Mercury. On leaving, he embarked on a somewhat chequered career in the advertising world and after being sacked from a dozen jobs in less than a decade he figured maybe photography could be more his thing. He quickly established an appalling reputation in the flea pits and clip joints of London, photographing punks, skinheads, new romantics and the like. Through a combination of bullshit and bluster he managed exhibitions at the ICA (Punk Portraits, 1978), Chenil Gallery (Skinheads, 1980), The Photographers' Gallery (The Kiss, 1982), The Photogallery (We are the Flowers in your Dustbin, 1983) and The City Centre Art Gallery, Dublin (One man show, 1990). Turning his so-called talents to the world of editorial portraiture, he managed to hold out long enough to do nearly 150 front covers for magazines like **The Face**, **NME**, **Time Out** and **Loaded**. 'Like' may be the operative word here; they say they've never heard of him.

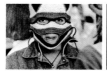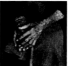

Dr Tim Rudman EFIAP, FRPS, FBPPA Hon, FRSA, ASIIPC, has built up an enormous reputation as a master printer and fine art photographer. He's contributed regularly to every major photographic magazine in the UK, is currently a feature writer for **Photo Art International**, and has produced two books. **The Photographer's Master Printing Course**, produced in 1994, has been a best seller since it was launched, and **The Master Photographer's Lith Printing Course** followed in 1998. Dr Rudman is also a Member of the London Salon of Photography, and has exhibited his work worldwide, having gained numerous international awards and gold medals in the process. He's also a previous AP/Ilford Printer of the Year Award winner, and he's a member of the Royal Photographic Society's Visual Arts Pictorial Panel and Chairman of the Photographic Printing Panel. He's conducted numerous workshops in the UK, Spain and Australia, and his work is represented in the Permanent Collection of the RPS, the Tyng Collection and various private collections.

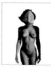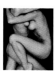

John Swannell is one of the UK's best-known and most successful photographers. He was born in 1946 and after leaving school at sixteen, he worked first as an assistant at Vogue Studios and then joined David Bailey for four years before leaving and setting up his own studio. He spent the next ten years travelling and working for magazines such as Vogue, Harpers & Queen, The Sunday Times and The Tatler. During this time he developed his very distinctive, individual style in both fashion and beauty photography. In 1989 he had a one-man show at The Royal Academy in Edinburgh, followed in 1990 by an exhibition at The National Portrait Gallery in Edinburgh. In July of the same year The Royal Photographic Society held a retrospective of his fashion work, and a year later a show of his nudes was exhibited at The Hamilton Gallery. John was awarded a Fellowship of the RPS in 1993, one of the youngest members to have achieved this status, and the following year The Princess of Wales personally commissioned a portrait of herself with her sons from him. From November 1996 to March 1997 John had a one-man show of his portraits at the National Portrait Gallery in London to celebrate the publication of his book **Twenty Years On**, and the pictures are now held in the Gallery's archives. The Victoria & Albert, the National Portrait Gallery in Scotland and the Royal Photographic Society also now have many of his works in their permanent collections. John has published three books to date: **Fine Lines** (1982), **Naked Landscape** (1986) and **Twenty Years On** (1996).

Randall Webb is a freelance photographer and lecturer. He is also a leading authority on the history and practice of photographic printmaking, ranging from the work of Fox Talbot in the 1830s to Andy Warhol in the late 20th century. His interest in early and alternative processing dates from his experiments in 1968 with the now neglected bromoil process. He now runs workshops at museums, art schools and universities on a wide variety of early processes, including salt printing, gum printing, platinum, carbon, photo etching and photo silk screen. Following extensive research, he has recently published a definitive text book on the subject entitled **Spirits of Salts**, in association with Martin Reed of Silverprint – website at http://www.silverprint.co.uk, email sales@silverprint.co.uk. A few years ago he founded the 120 group of photographers, and he exhibits and sells his work which is printed using examples of alternative printing.

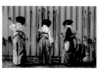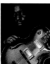

Gary Wilson was born in 1964, and left graphic design for photography in 1986. He began working in black-and-white darkrooms specialising in theatre photography, with associated large scale printing for front-of-house display. He also produced large scale prints for exhibitions taking place at venues such as the Victoria & Albert Museum, the Theatre Museum in Covent Garden, the Press Photographers' Association, Nikon and individual photographers such as Brian Griffin and Chris Killip. A personal interest in reportage photography also led to associations with many photographers in the news and photojournalism fields, many of whom became regular clients when he turned freelance in 1991. This also allowed Gary to expand his own photographic career, which is largely arts based, and which includes commissions for music, portraiture and commercial/design assignments. He also enjoys maintaining a level of diversity with his printing clients, concentrating on portfolio, exhibition and sale work, as well as fast turnaround printing for advertising and commercial work.

Andreas Zacharatos was born in Athens in 1961. He studied cinema and television, and taught photography from 1984 to 1985. Until 1989 he was working in private TV studios as an operator and director of photography, and since that time he has been working as director of photography in the second state TV channel in Greece. From 1996 he has also been teaching Direction of Photography in the IEK of eastern Attika. His distinctions have included the First European Prize of Photography in a competition organised by the European Community's Ministries of Tourism in 1990, First Prize in the Rollei Club's International Photo Salon of Great Britain in 1996 and a high placing out of a field of 49,000 participants in the International World Heritage Photo Competition run by UNESCO in 1997. He has mounted several exhibitions at venues all over Greece, most recently showing his Jazz Moments set at the Aegean Festival on Rodos Island and at the Art Gallery in Chania, Crete in 1997. Andreas can be reached by email on: annina@otenet.gr.

Glossary

Backlighting
Light that's coming from a position in front of the camera and illuminating the subject from behind.

Black Reflector
Used to soak up light and to ensure that a selected area retains deep shadow.

Bounced Flash
Flash that's been reflected from a surface such as a wall or ceiling to diffuse the light.

Cable Release
A flexible device that screws into the camera's shutter release button and activates the shutter without the need to touch the camera.

Camera Movements
Vertical and swing movements that can be made with the lens and the film plane on a studio camera to perform various functions, such as increased depth of field and correction of converging verticals.

Compressed Perspective
Distant perspective that's been brought up close by the use of a telephoto lens.

Depth of Field
The distance in front and behind the point at which a lens is focused that will be rendered acceptably sharp. It increases when the aperture is made smaller, and becomes smaller when the lens is focused at close quarters.

Dodging
The holding back of certain areas of the negative during printing to reduce print density, allied to the selective increase of exposure to certain areas of the print that require increased density.

Downrating
The opposite to uprating, and primarily done to reduce contrast. The film is shot at a lower ISO rating and, to compensate for what is effectively overexposure, the film is developed for a shorter time.

Dual Toning
The technique of placing a print in two separate toning baths to pick up elements of both colours.

Farmer's Reducer
A mixture of potassium ferricyanide and sodium thiosulphate that will lighten selective areas of a print.

Field Camera
A large format camera that has been specially designed to be used on location.

Fill-in Flash
A weakened burst of flash that can be used to subtly fill in the shadows on a subject's face.

Filter Factor
An indication of the amount the exposure needs to be increased to allow for the use of a filter. A x2 filter needs one stop extra exposure, x3 one-and-a-half stops more and x4 two stops more.

Fresnel Lens
The front of a fresnel lens consists of concentric rings, each of which forms part of a curved lens surface. These have the same overall convergent effect on illumination as a thicker lens, but the lens loses the heat applied to its inner surface through convection and radiation from its larger external surface area.

Graduated Neutral Density Filter
A filter that features a denser area towards its top that helps to even out the contrast levels in a picture if the sky is much brighter than the rest of the scene (see **Neutral Density Filter**).

High Key
A picture that consists almost entirely of light tones.

Hyperfocal Distance
The distance between the lens and the nearest point of acceptably sharp focus when the lens is focused for infinity.

Infrared film
A film that responds to the different reflecting powers and transparencies of objects in the picture to infrared and visible radiation, producing a series of bizarre tones.

Lith Printing Paper
A printing paper that increases the contrast levels in a scene while allowing shadow detail to be retained. Its characteristic feature is a pink tone.

Low Key
A picture that consists almost entirely of dark tones.

Mirror Lock
A lever on an SLR camera that allows the camera's mirror to be locked in the up position before an exposure is made to help reduce vibration.

Monopod
A form of support for the camera that utilises one leg, which makes it very easy to set up and move.

Neutral Density Filter
Used to cut down the light reaching a film by a stated amount, and absorbs all wavelengths almost equally, ensuring no influence on the tones each colour will record as on black-and-white film.

Pinhole Camera
A camera that relies on a tiny hole to resolve its image rather than a lens.

Polaroid Type 55 film
One of the oldest Polaroid film materials available, which gives the photographer both a print and a negative.

Rangefinder Camera
A camera that features two separate images in the viewfinder that come together as the lens is focused.

Reflector Brolly
A highly reflective umbrella that attaches to a flashgun to bounce the light back onto a scene.

Selenium Toning
A brief immersion in selenium toner diluted at about one part concentrate to 15 parts water should not change print image colour but it will improve the archival permanence of the print. The toner must be used in well ventilated conditions.

Spot Meter
A meter that is designed to give an accurate meter reading in difficult lighting conditions by gathering information selectively from three to four areas of a scene.

Tapestry Paper
Manufactured by Fotospeed, this is a heavyweight paper with a textured finish.

Thiocarbamide toning
A two-bath process that can, according to relative strengths of the components in the toning stage, give a variety of tones ranging from dark brown to yellow brown.

Uprating
Rating a film at a speed higher than its nominal rating, and then compensating for the underexposure that takes place by increasing film development.

Variable Contrast Paper
Photographic paper that can produce different levels of contrast depending on the filtration it receives.

White Reflector
A board or sheet that is positioned to bounce light into areas of shadow.

Acknowledgements Many thanks to all those who have contributed so very much to this book. To Angie Patchell, who has overseen and edited the whole project, and whose enthusiasm has helped immeasurably to drive it forwards; to Dan Moscrop at Navy Blue Design Consultants, who has worked so hard to turn a collection of pictures into a cohesive and visually stunning volume of work; to Brian Morris at RotoVision, whose belief and support for the project has been invaluable; to all the photographers who have contributed their work and their expertise so willingly, and who had faith in the book when it was a mere twinkle in the publisher's eye; and to Sarah and Emilia, who lost me for virtually an entire summer, and never once complained.

The Association of Photographers

Based in London, the Association of Photographers has a membership of advertising, editorial and fashion photographers, and photographic assistants, in excess of 1,400, and it's also supported by agents, printers, manufacturers and suppliers of photographic equipment, as well as affiliated colleges. The Association, which supports a large and superbly presented gallery, is dedicated to fighting for photographers' rights in addition to promoting the work of contemporary photographers. Contact details: 020 7739 6669, email: aop@dircon.co.uk or visit the website at www.aophoto.co.uk.